Portraits Drawing

Learn How to Draw Human Portraits

By Alex Richards

Copyright©2016 Alex Richards
All Rights Reserved

Copyright © 2016 by Alex Richards

All rights reserved. No part of this publication may be reproduced, distributed, or transmitted in any form or by any means, including photocopying, recording, or other electronic or mechanical methods, without the prior written permission of the author, except in the case of brief quotations embodied in critical reviews and certain other noncommercial uses permitted by copyright law.

Table of Contents

Introduction	5
Chapter 1 Basics of Portrait Drawing	7
Chapter 2 Elements of a Face	11
Chapter 3 Portrait of Ana (female)	25
Chapter 4 Portrait of Christy (female)	34
Chapter 5 Portrait of Francesca (female)	46
Chapter 6 Portrait of Alexis (male)	59
Chapter 7 Portrait of Jacob (male)	74
Conclusion	86

Disclaimer

While all attempts have been made to verify the information provided in this book, the author does assume any responsibility for errors, omissions, or contrary interpretations of the subject matter contained within. The information provided in this book is for educational and entertainment purposes only. The reader is responsible for his or her own actions and the author does not accept any responsibilities for any liabilities or damages, real or perceived, resulting from the use of this information.

The trademarks that are used are without any consent, and the publication of the trademark is without permission or backing by the trademark owner. All trademarks and brands within this book are for clarifying purposes only and are the owned by the owners themselves, not affiliated with this document.

Introduction

Drawing human faces is considered as the most complicated part of sketching. However, no feat is difficult to achieve if you practice deliberately. Becoming an expert is drawing is just like becoming the master of any other sport. Every sportsperson starts the journey of learning one day and gradually learns the tricks and tips of the game. Similarly, if you give appropriate time and dedication to drawing portraits, nothing can stop you. Practically, learning portrait sketching does not take more than a month.

The first few days can be dedicated to learning basic outline drawing of the face and its features. Then, you can proceed to refining these features. In the first few chapters of this book, you will find guidance to draw the facial features, particularly eyes and hairs, in detail. In the forthcoming chapters, you will find different portraits of females and males. One chapter is particularly bestowed to the drawing of facial features in complete details. It will give you a closer look to the depth of eyes, lips, and nose.

Even though the portraits given in this book are made using computer software, you can draw them using your own regular equipment for drawing. Normally, the following things are needed to start pencil drawing or charcoal drawing: pencils (2H to 8B), rubber eraser, cutter blade, charcoal stick, and a rag.

These basic things are needed to start your amazing journey to portrait drawing. Regarding the choice of drawing sheets, you do not have to go for fancy sheets. Just a bunch of A3 cartridge sheets is enough. These sheets are very good at depicting the gradations of charcoal.

At last, you just need to dedicate your time to portrait drawing. When you start drawing, a full- fledged portrait may take up to a week to complete, if you give an hour daily. However, when you become an expert at portrait drawing, you may complete a detailed sketch in just 4-5 hours at a stretch.

Do not wait for the right time to come when you would start drawing. This is the right time; just grab your stuff and sit down to draw.

Chapter 1
Basics of Portrait Drawing

Drawing portraits seems difficult no doubt, but it can be made easy provided you know the right tricks. You do not have to be a decade old artist to learn drawing portraits; only a few weeks of experience is enough. First, choose a photograph that is rich in content, implying that there are variations in contrast, tonal value and the photo must be shot or printed in high resolution. You might find it difficult to find such photograph on Internet. If that is the case, you may have to get a photograph click of yourself or of someone else. Do not start your beautiful journey with a photograph with low resolution.

If you have a digital photograph, make it black and white, or convert it into grayscale. Now, crop the picture to get the size of face you want and print it. You will be able to view the tonal values clearly. Look at the picture carefully and determine the source of light, facial feature including eyes, nose, teeth, lips, ears, hairs, etc. When the hairs are light in color, you have to draw shadows among them, which is known as negative space drawing.

Notice if there are any wrinkles. If they are there, it is good news as well as bad news for you. The good news is that wrinkles bring life to a portrait, but they are hard to draw. They are like deep valleys with irregular shading on each side. Eyes and ears have wide range of tonal value. You can either draw each shade separately, or give darker shades first and then erase the graphite to give highlights. In any case, you have to be very patient and have a vision.

Notice the clothing of your subject. If there are many variations in design and tonal value, you will have to invest even more time. Therefore, try to crop your portrait to a proportion that face covers most of the area and only a small amount of clothing is visible; though you cannot eliminate clothing.

How to draw eyes

Eyes in a portrait are the most expressive and most difficult thing to draw. But do not get disheartened, they can be easily learned. It is important to observe the eyes closely before you start drawing. There are significant differences in the lines of lower and upper eyelids. The closer you observe, the more likeliness will be achieved.

The upper eyelid always covers some portion of the iris. A common mistake beginners make is to draw the iris small and then fit in within sclera. The lower portion of the iris is very slightly covered by the lower eyelid. You need to consider these two elements when you draw the glassy shell of the eyes:

- The bright spark of the reflected light must be left blank/un-shaded sheet of paper when you begin tonal drawing. It will be the brightest part of the eyes. When the pupil is drawn in contrast, this bright portion is further augmented.

- The iris consists of a variation of flecks and tones, which radiate in the middle of pupil. The iris is darker on its exterior edge and lightens on the interior creating a lucid effect.

The last step is to execute solidification in the socket of the eye and the surrounding region using gradations.

The upper eyelid throws a shadow that creates a dark curve on top of eyeball, which slowly softens into shaded area in the eye's corner. Graduated shading can be done to give details to the outline and give tonal variations to the eyelids along with the surrounding regions. Eyelashes and eyebrows are made of delicate, soft hairs. Therefore, draw them with precision and pay attention to their direction of growth.

How to draw hairs

After eyes, hairs are the trickiest portion of a portrait to draw. However, once you achieve the required skills, you will fall in love with drawing hairs. Begin drawing the hair with a base layer- start drawing the black region with charcoal, and then smooth it using the flat surface of an eraser. You can also use a cloth or tissue to smudge charcoal. Create the strands of the hairs by using an eraser cut from its corner. You can keep cutting a thin edge of the eraser until you are done with drawing strands of hairs.

The erased white lines appear as if light reflects on the hairs. Draw darker lines using charcoal and ensure that your lines should be as thin and narrow as possible. Even in the darkest portion you see in your reference photograph, there are some fine lines that depict strands of hair. If you leave a patch of charcoal in a particular area of the head, it will look really odd. You can make minor changes in the direction of strands since hairs give you slight scope of flexibility.

Chapter 2
Elements of a Face

Before you sit down to draw a portrait, you need to understand the basic anatomy of a face. We cannot state a fixed rule for drawing a portrait since every face is different and there are no fixed sizes for the eyes, nose, lips, or ears. However, you can have an approximate judgment where these facial features should be placed in the frame of a face.

Steps to draw a face

Draw the outline of the face you want to draw. Sketch a vertical line in the center of the face. Now, draw a halfway horizontal line between the lower base of the jaw and the apex of the head (where the hair ends on top of the head). This line will be used to place the eyes. Then, halfway between the chin and eyes, draw a line to place the nose. Halfway between the chin and the nose, draw a line to place the center of mouth. It is important to note that there is a distance of one eye between both eyes. The ears are usually as long as the distance between eyes and base of nose. The length of lips is equal to the distance between two irises of the eyes if they focus straight.

A few examples of face outlines

Face 1

This is the face of a woman and it is drawn as told in the instructions given above. The ears are not shown in this face.

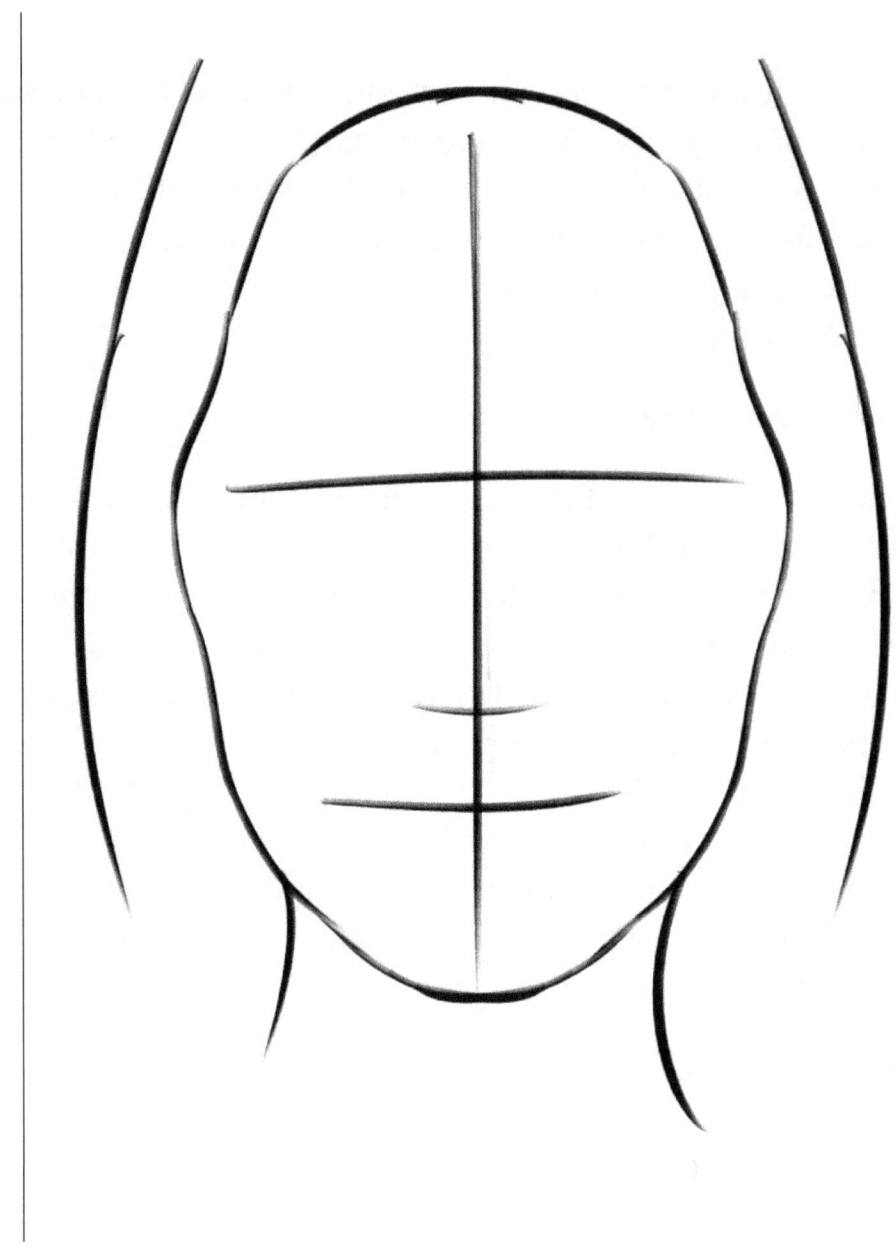

Face 2

This is the face of a young man. Here you can clearly see that the lower line for the placement of eyes is drawn exactly between the apex of the head and the lower base of chin. The other lines for the placement of facial features are also drawn as told above.

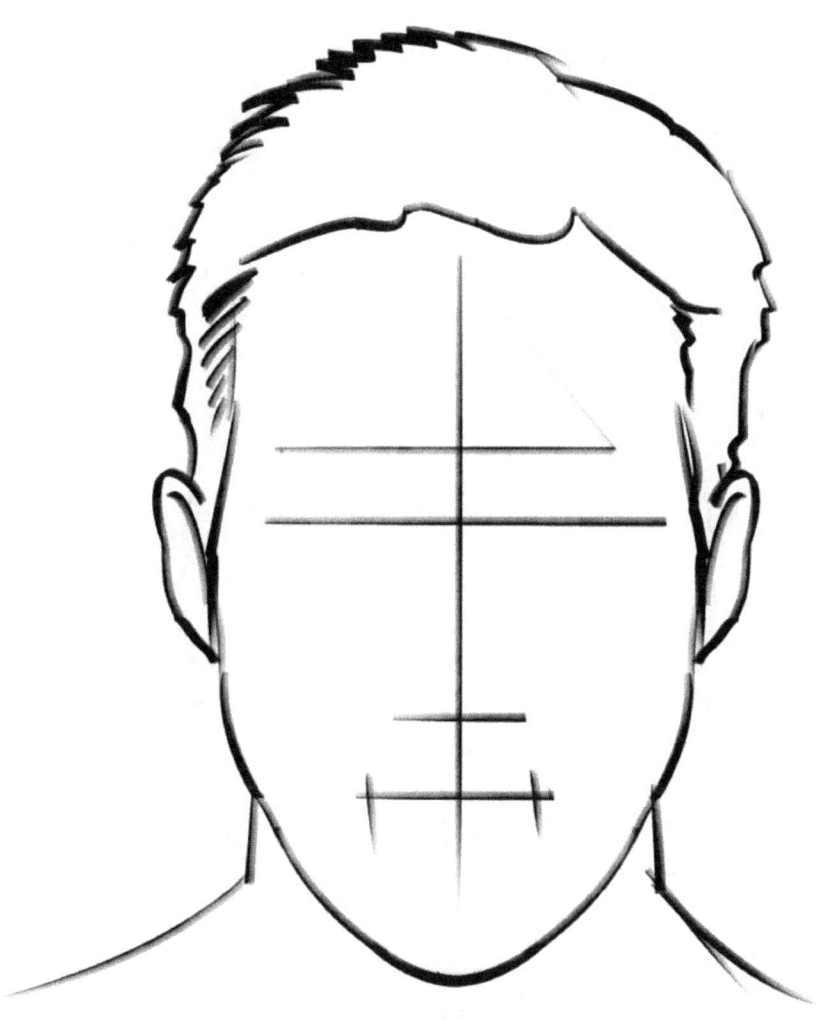

Face 3

This is the face of a teenager. Sometimes, you do not need many things to judge a face. The hairstyle of this boy is enough to say that this is going to be the portrait of a teenager or a man in his 20s.

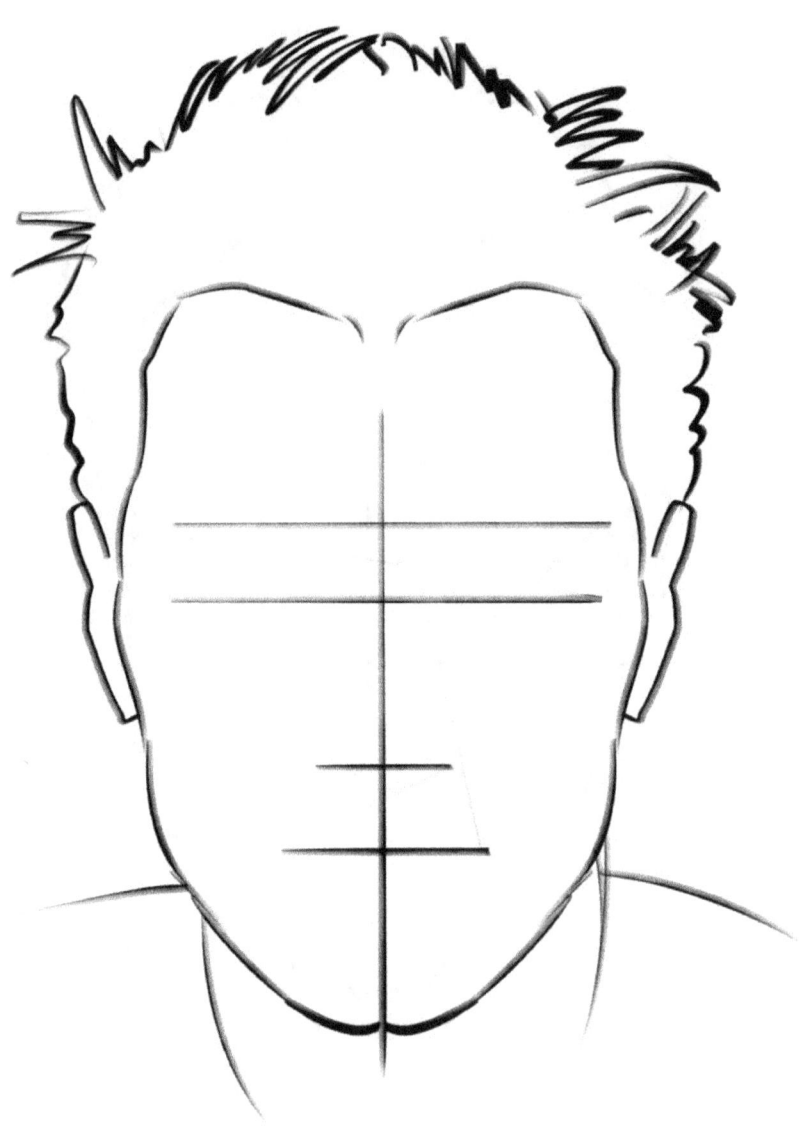

Eyes

Eyes are the most expressive feature of the face. They are capable of expressing hundreds of emotions just by little modifications. Let us go through a few expressions of eyes of males and females.

Eyes 1- hopeful eyes (female)

With a side-glance, this female is depicting hope in her eyes. Notice that the strands of eyebrows are drawn in different directions the eyelashes are also drawn in different lengths. If you observe closely, you will see fine white lines on the inner edge of the eyes, the sclera is not blank white, sclera consists of shadow cast by the upper eyelid, the reflection of light near the iris is blank white, there are different gradations within the eyeballs, and many more things.

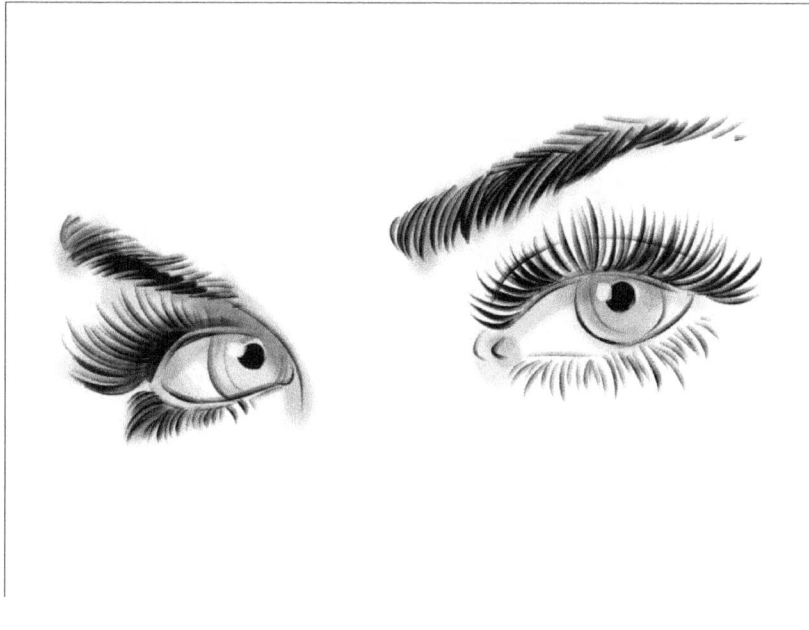

Eyes 2- sharp eyes (female)

This set of eyes also belongs to a female who is sharply looking at you. Just like the previous set of eyes, there are differences in different elements. No two set of eyes are same, therefore, you must carefully observe all the elements of an eye.

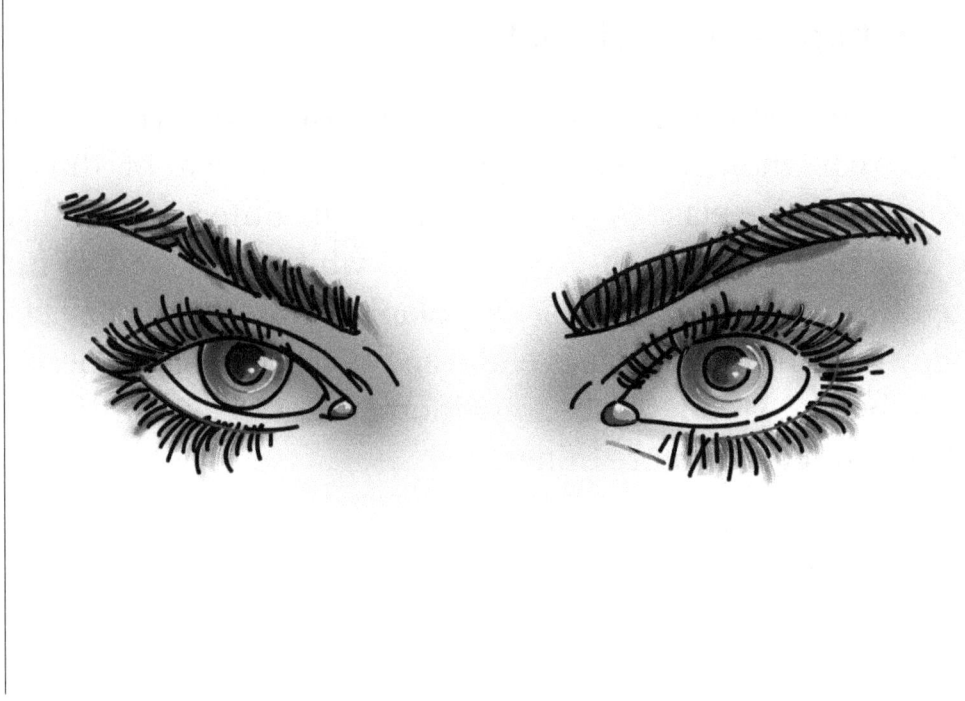

Eyes 3- irritated eyes (male)

The eyebrows of males are generally thicker than that of females. This man's eyes depict that he is irritated at something just by squinting his eyes a little. There is an arc under his right eye. You can use wrinkles around the eyes to depict age and expressions of a person.

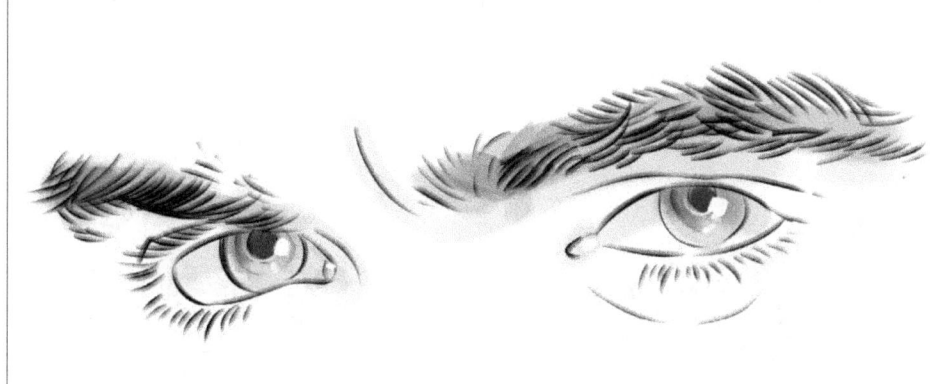

Eyes 4 - revengeful eyes (male)

When a person bends his head a little and looks straight ahead, the eyes give a scornful or revengeful look. This man's eyes are giving the same vindictive look. Notice that there are differences in the shape of left and right eye, which is very common in humans. The eyes of a person can be significantly different to each other. The difference is not visible at a distance, but when you look closely or at portrait photography, you may notice the difference.

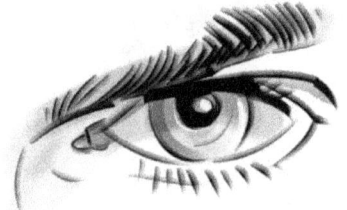

Lips
Gratified lips

These female lips denote gratification with food or something else. Lips are the second most expressive feature after eyes. That is why; you need to draw the lips and teeth with precision. The lips also consist of many fine lines, which contribute to the quality of your drawing. While drawing teeth, you must notice that teeth are never flat white in color. Most people have off-white color of teeth. Even if the color of the teeth is consistent, you will definitely notice shadow of lips on the teeth.

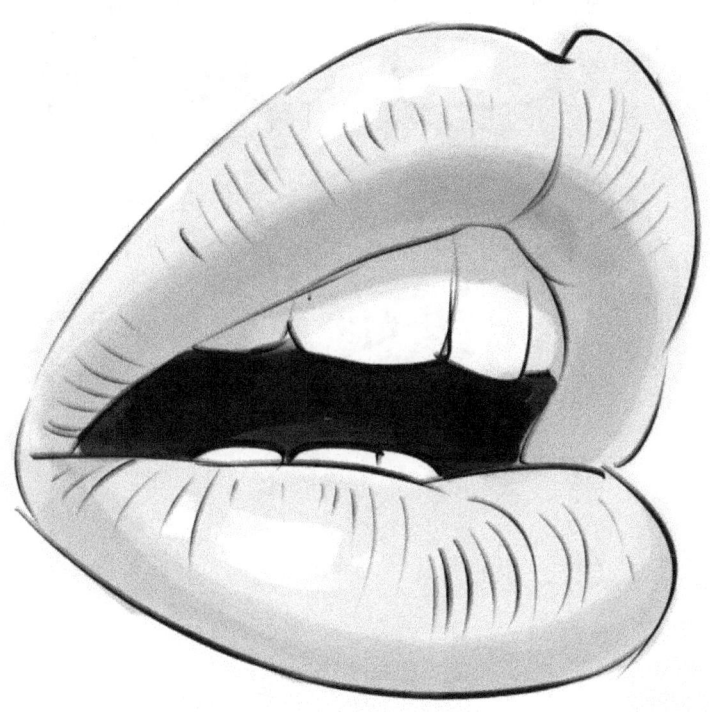

Lips 2- lusty lips

These lips also belong to a female. She has slightly tucked her lips with her teeth, which gives a lusty look to her lips. Notice that there are abundant fine lines in her lips, which give rise to different tonal values. Since the lips are tucked with the teeth, the shape of the lips is considerably different from normal.

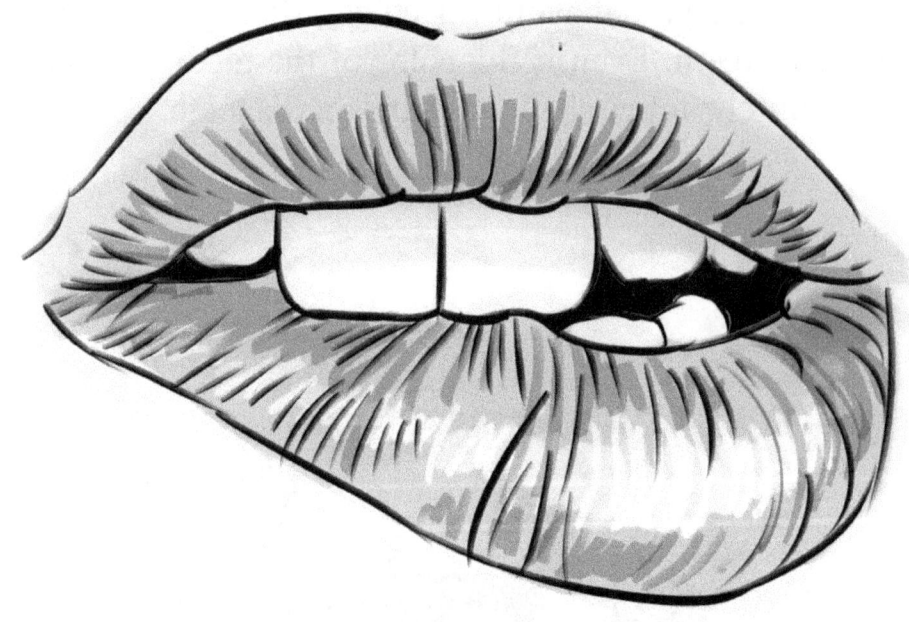

Nose

Nose is very easy to draw because it hardly contributes to expressing emotions in a face.

However, you have to be very careful while drawing a nose. Since nose does not have well defined boundary, you have to give it the required shape just by using gradations for the maximum part. If you are drawing a nose from the side profile, much of your work is reduced because you can give a definite shape to the nose. Only one nostril has to be drawn from the side profile.

Nose 1

This nose is drawn from the side profile. There is a bump in the bridge of the nose, which is depicted by small arcs.

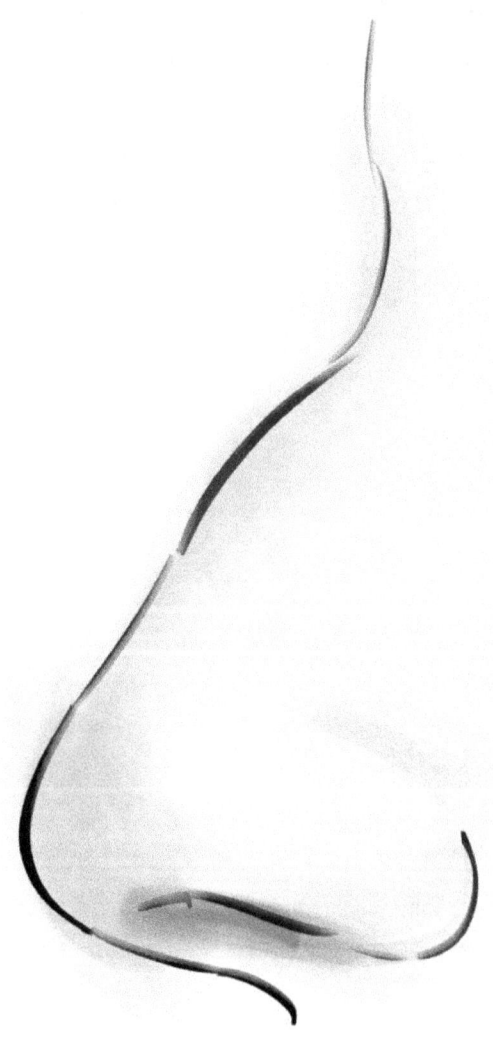

Nose 2

This nose is drawn from the front profile. Notice that there are hardly any lines drawn to depict the bridge of the nose. Only the nostrils and their sides have to be drawn with definite lines.

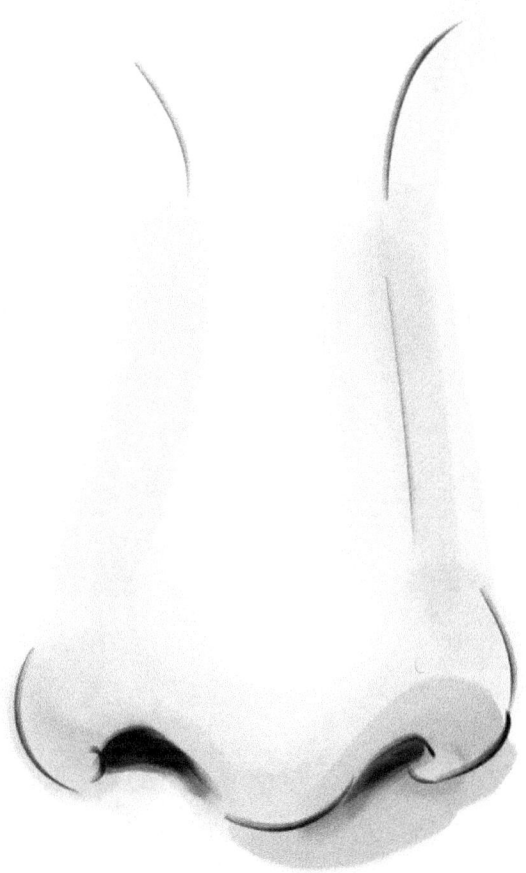

Nose 3

This nose is also drawn from a side profile. Hence, it does not require much effort in drawing.

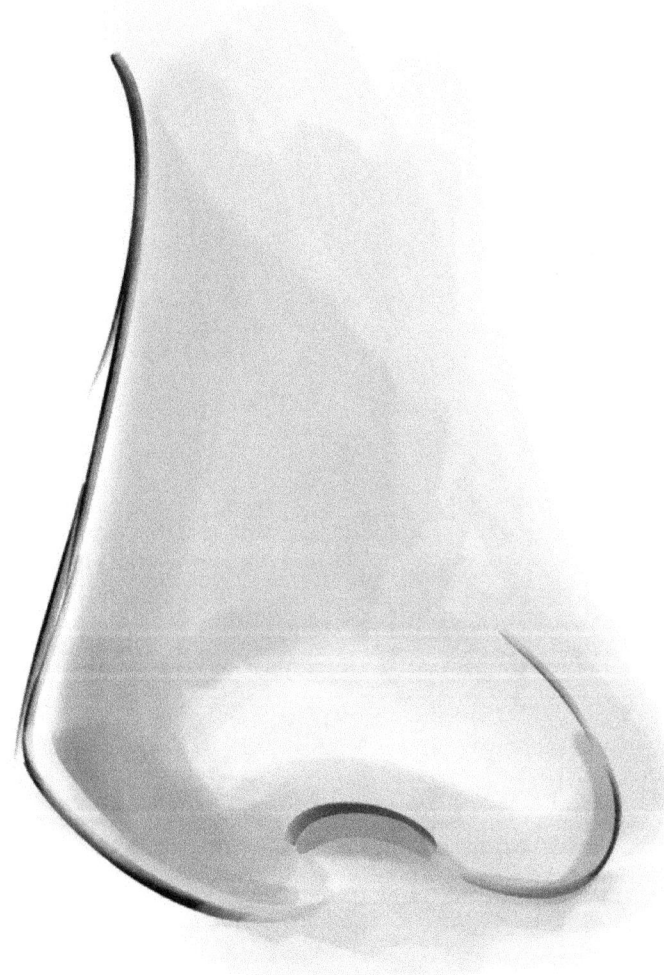

Chapter 3
Portrait of Ana (female)

Step 1
Draw the basic outline of Ana from the side profile. The lady is sitting straight but her face is turned sideways.

Step 2

Draw the lines to place eyes, nose, and lips. Notice that her right ear falls between the eyes and nose. Draw her clothing as she is wearing a collared shirt.

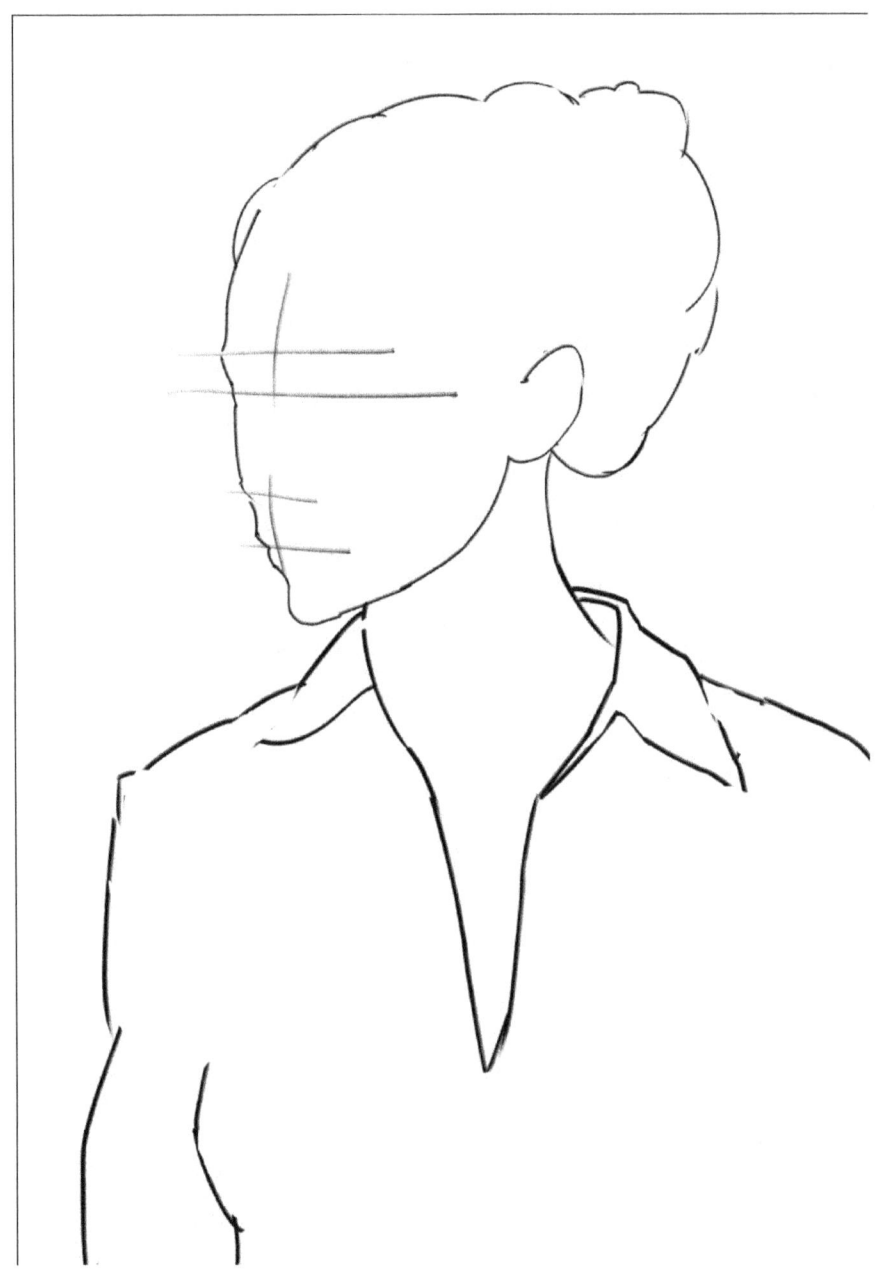

Step 3

Draw the eyes, nose, lips, and ears with slight details. The left eye and lips are not completely visible since Ana is looking sideways.

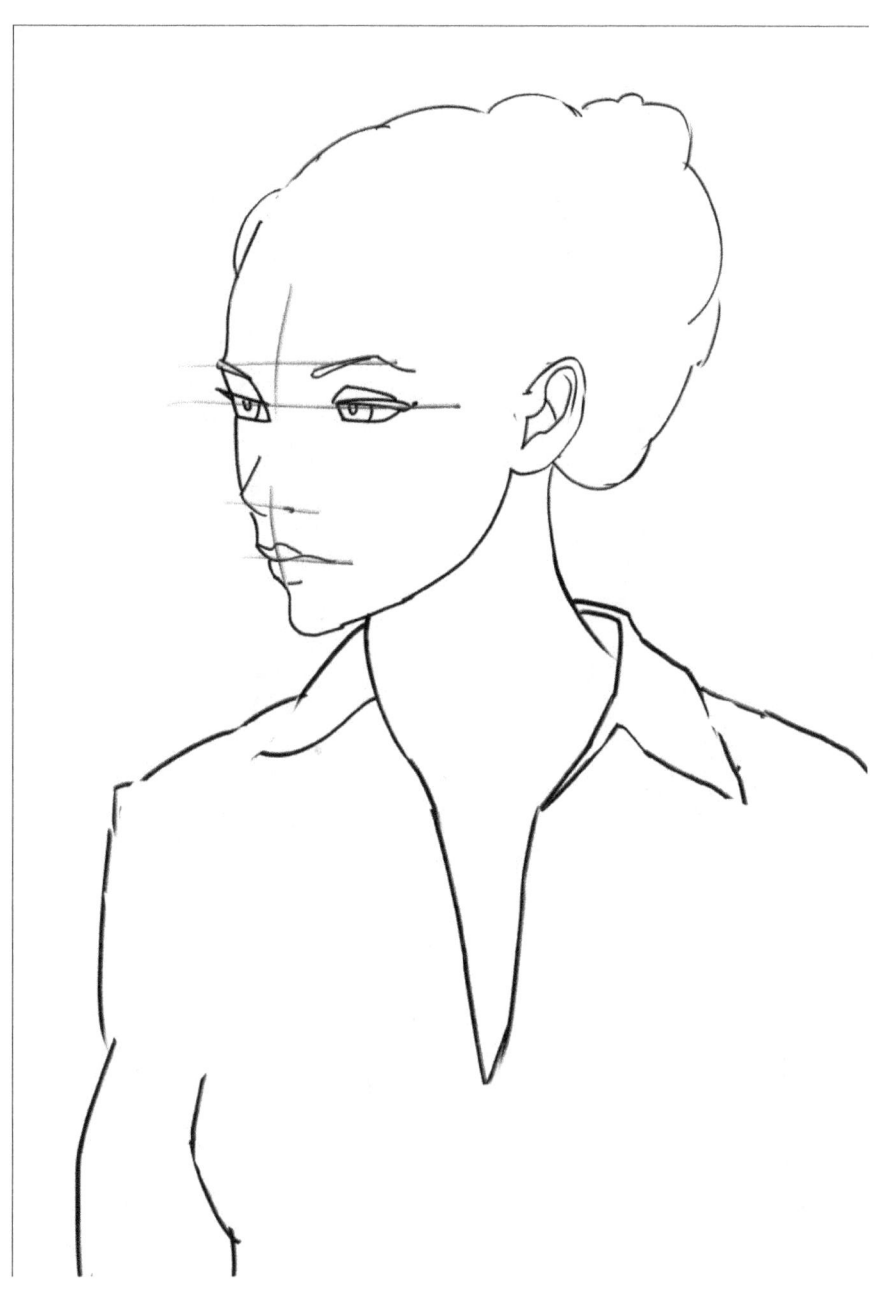

Step 4

Draw strokes to depict strands of her hairs. The hairs never fall in the same direction. Therefore, draw the strands in different directions.

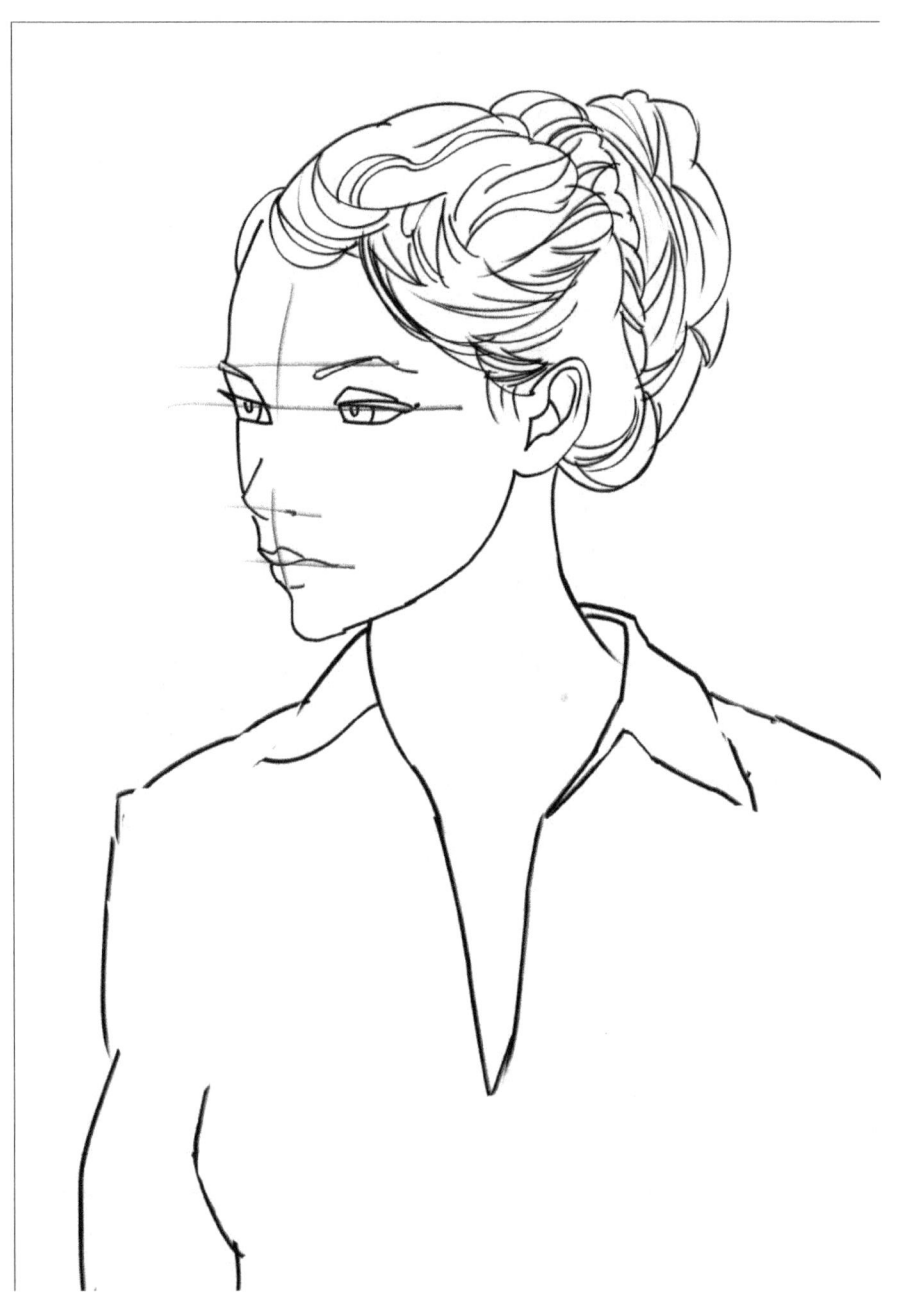

Step 5

Draw the buttons of her shirt and the pockets. Notice the creases on her clothing. These details are crucial to characterize a portrait.

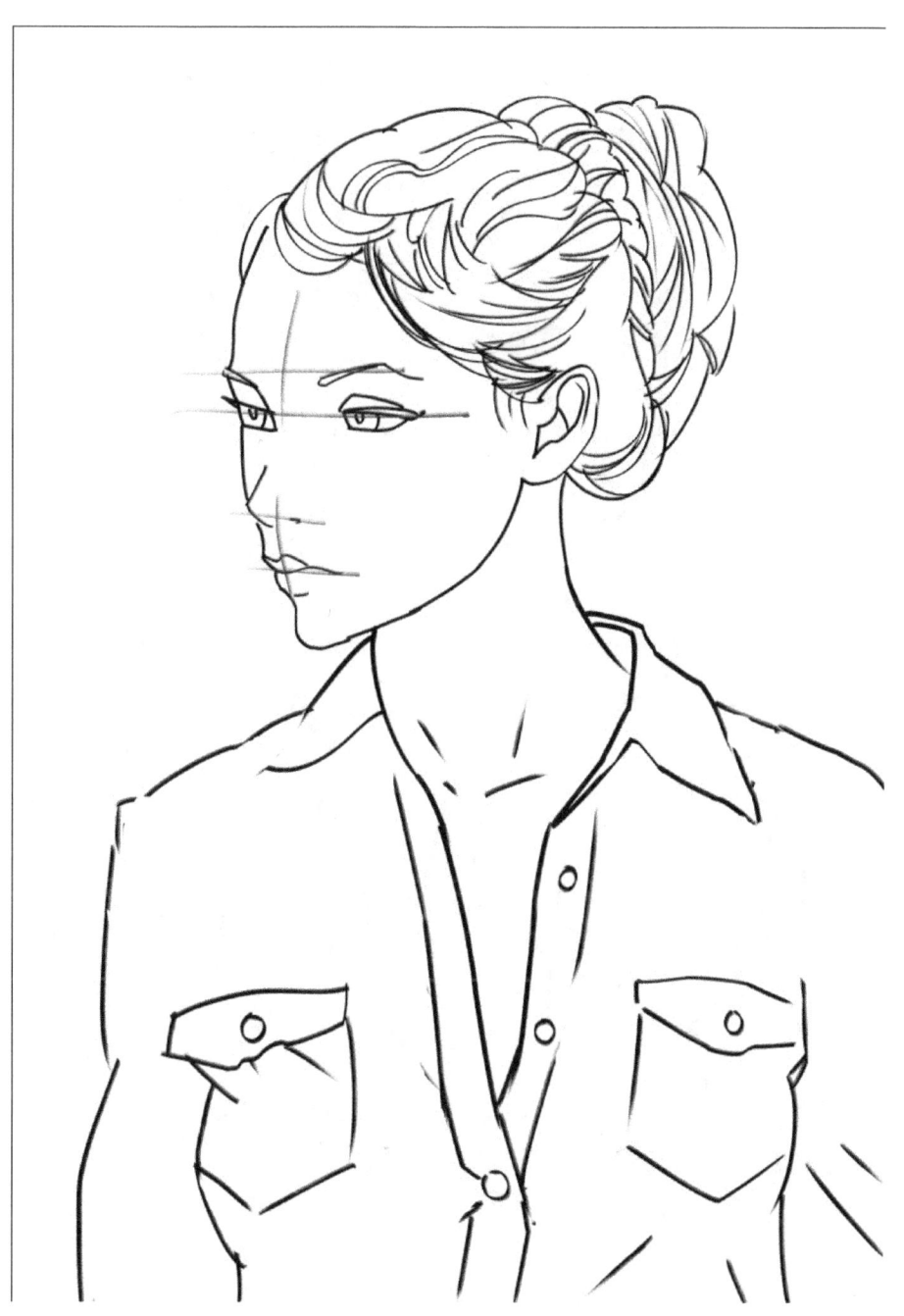

Step 6
Draw a few more creases in her shirt.

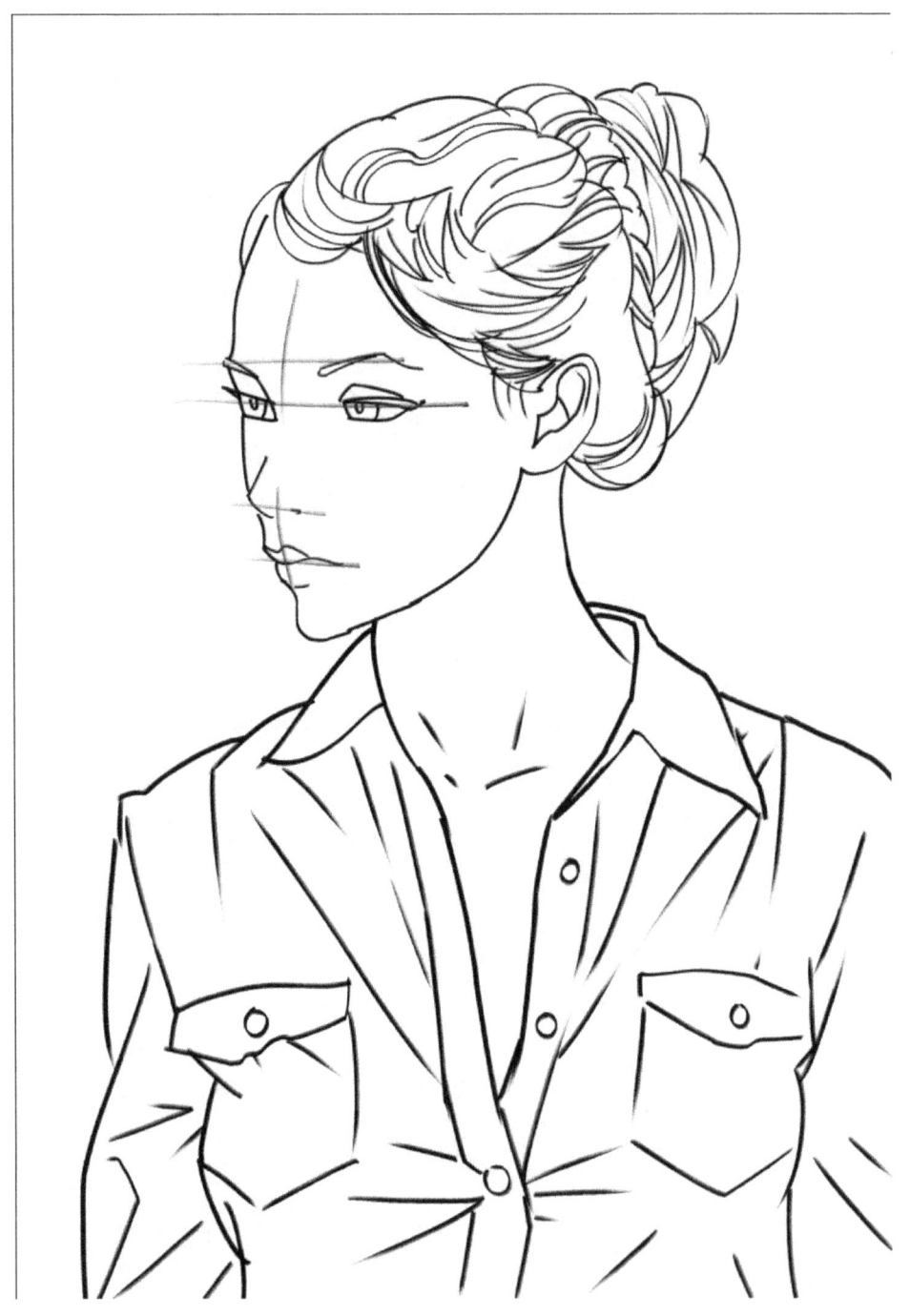

Step 7

Erase the lines from the face that were used to place the features. Since these vertical and horizontal lines have to be erased later, you must draw them with lighter shade of pencil.

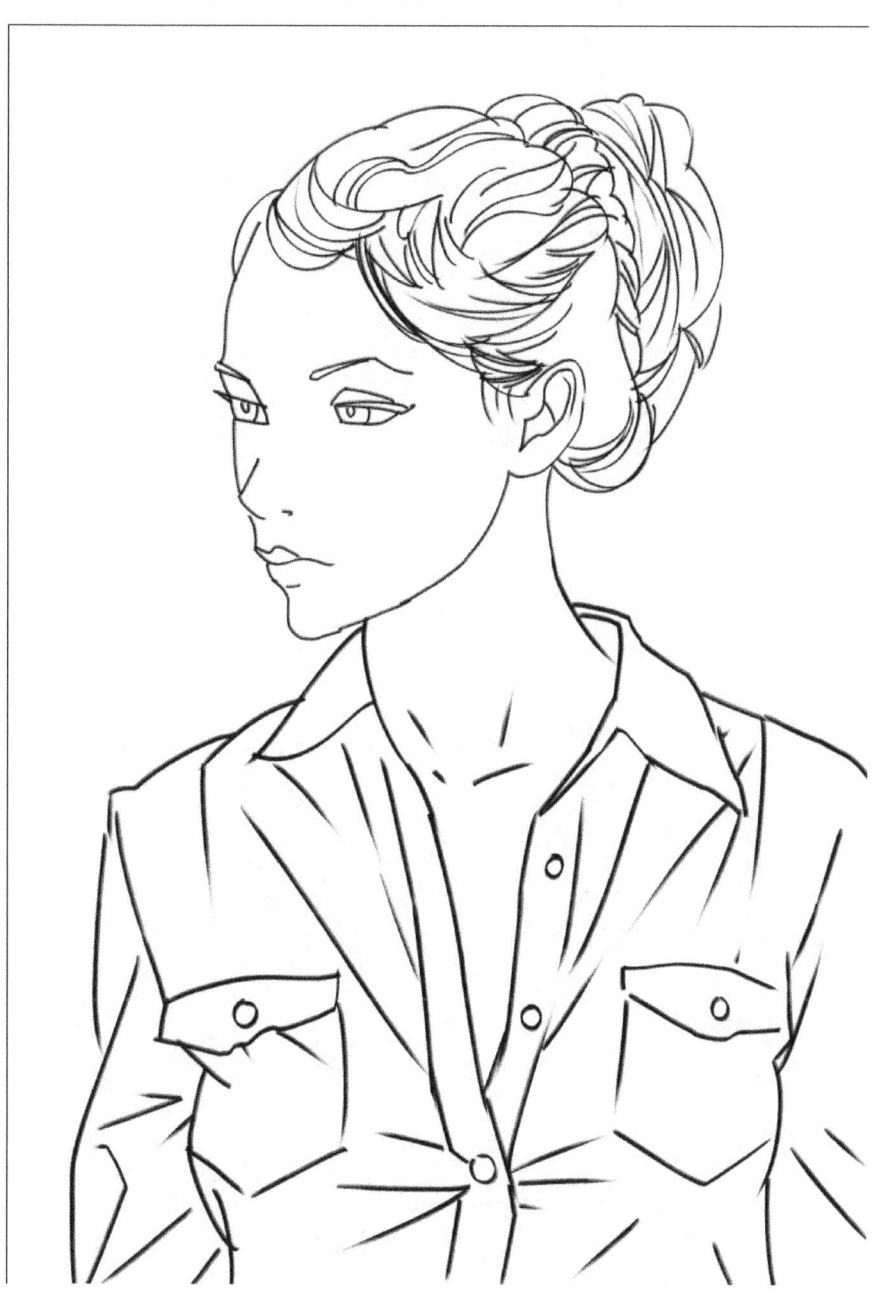

Step 8

Now, start giving shading slightly in different parts of the portrait of Ana.

Give shading in her eyes and most part of her shirt.

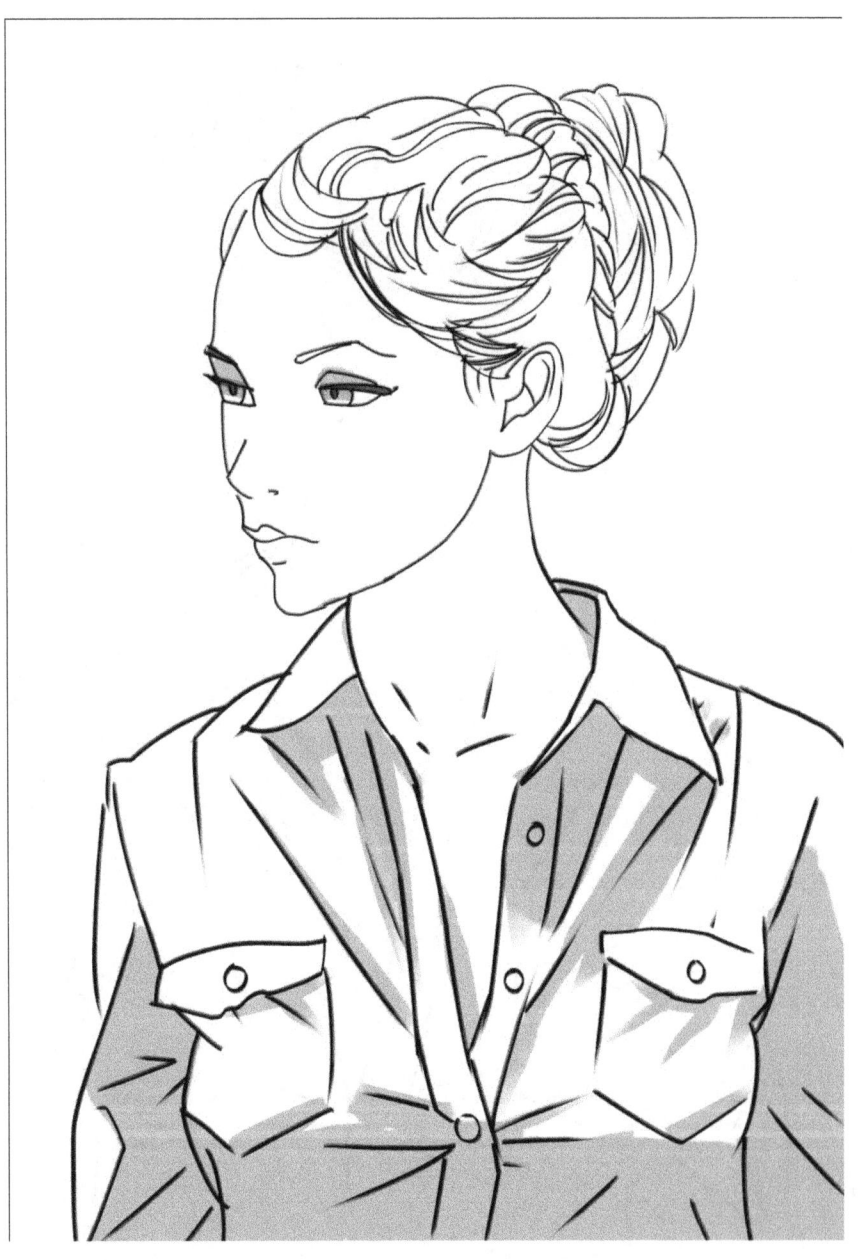

Step 9

Give shading in her hairs, face, and neck. The portrait of Ana is complete.

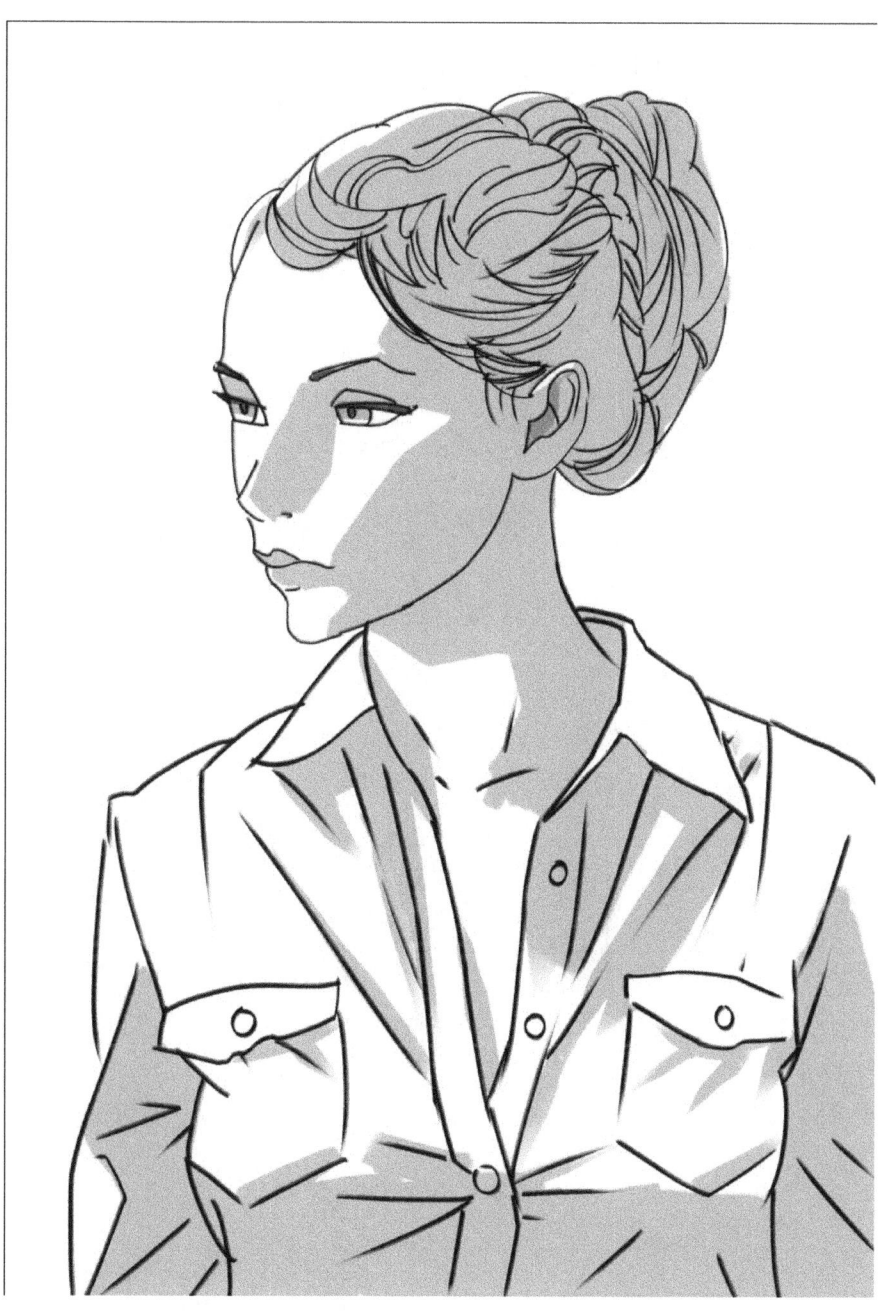

Chapter 4
Portrait of Christy (female)

Step 1

Draw the basic outline of the face of Christy. Draw the vertical and horizontal lines to place the facial features such as eyes, nose, and lips.

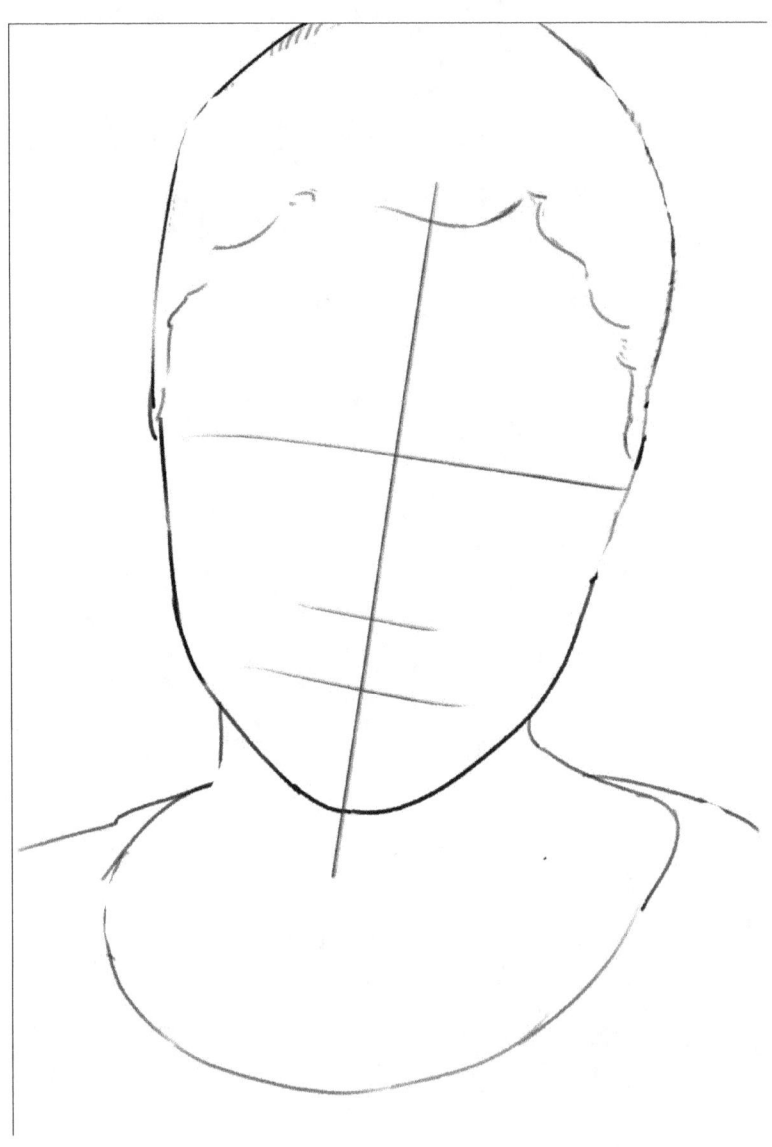

Step 2

Draw her ears and hairs. Since Christy has tied her hair at the back of her head, you do not have to draw the strands in different directions. The strands are pulled back in more or less same direction. Only a few curls of the hairs are visible.

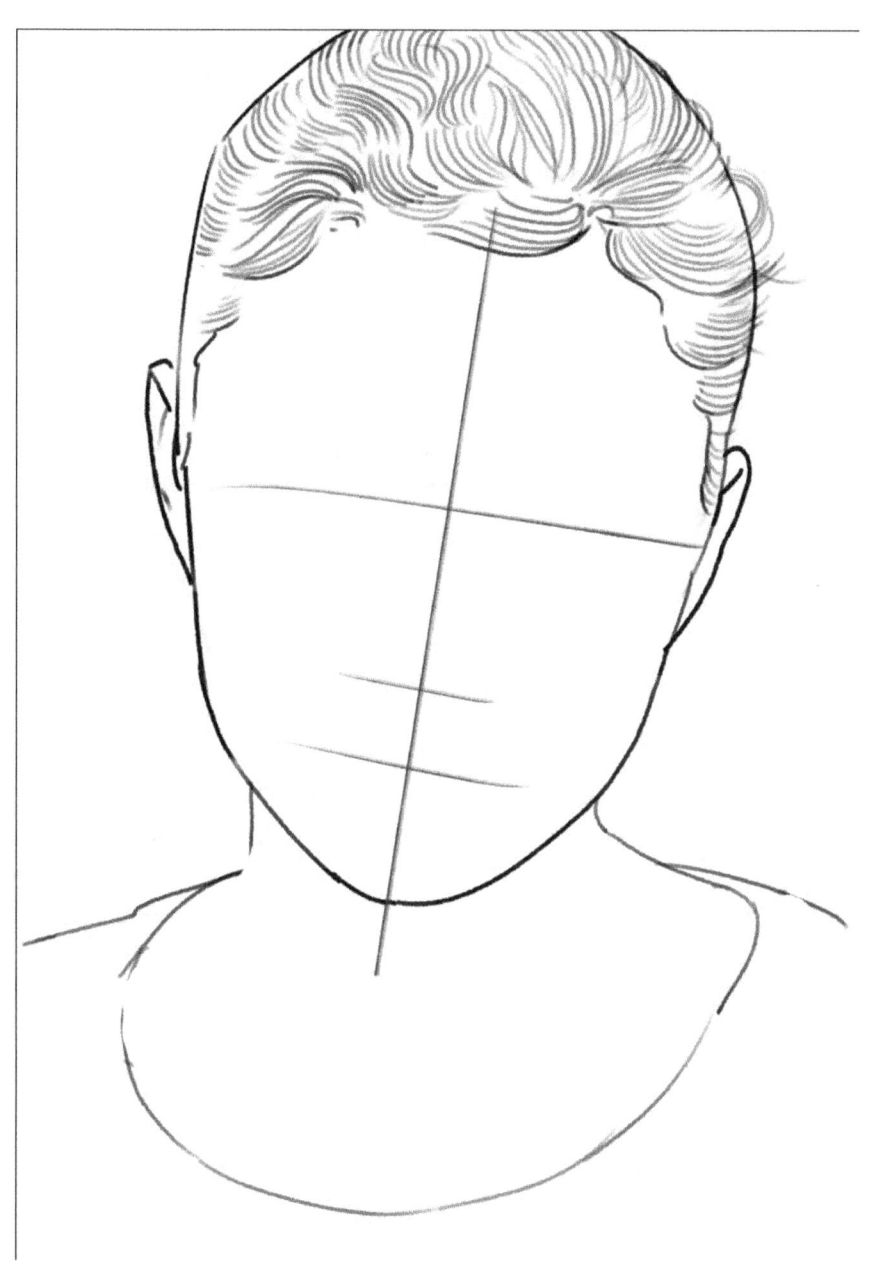

Step 3
Give details to the clothing of Christy. She is wearing a round neck T-shirt and hence, her beauty bones are visible.

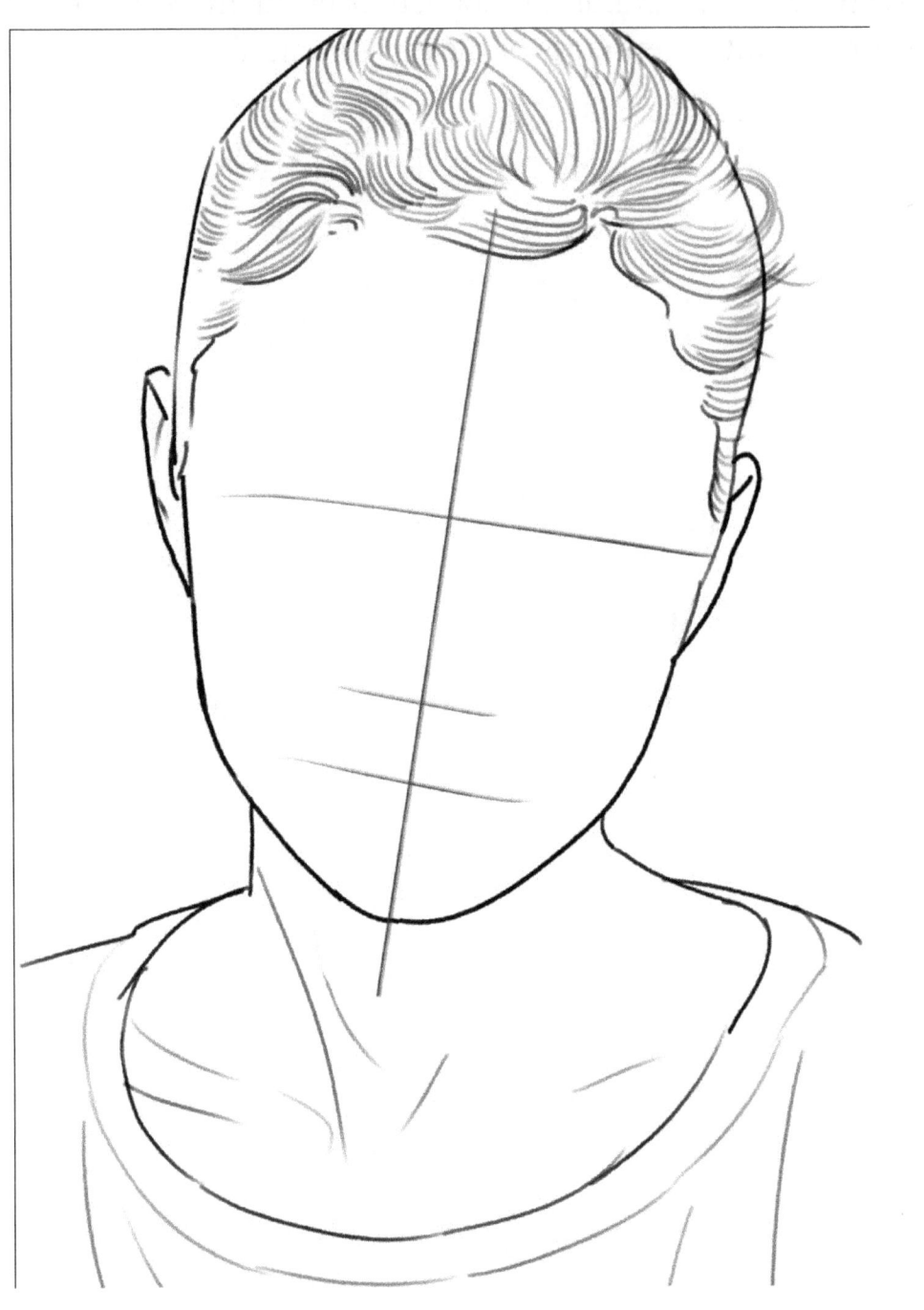

Step 4

Draw the eyes, eyebrows, nose, and lips of the woman. Since she is looking straight at you, you can clearly define her features.

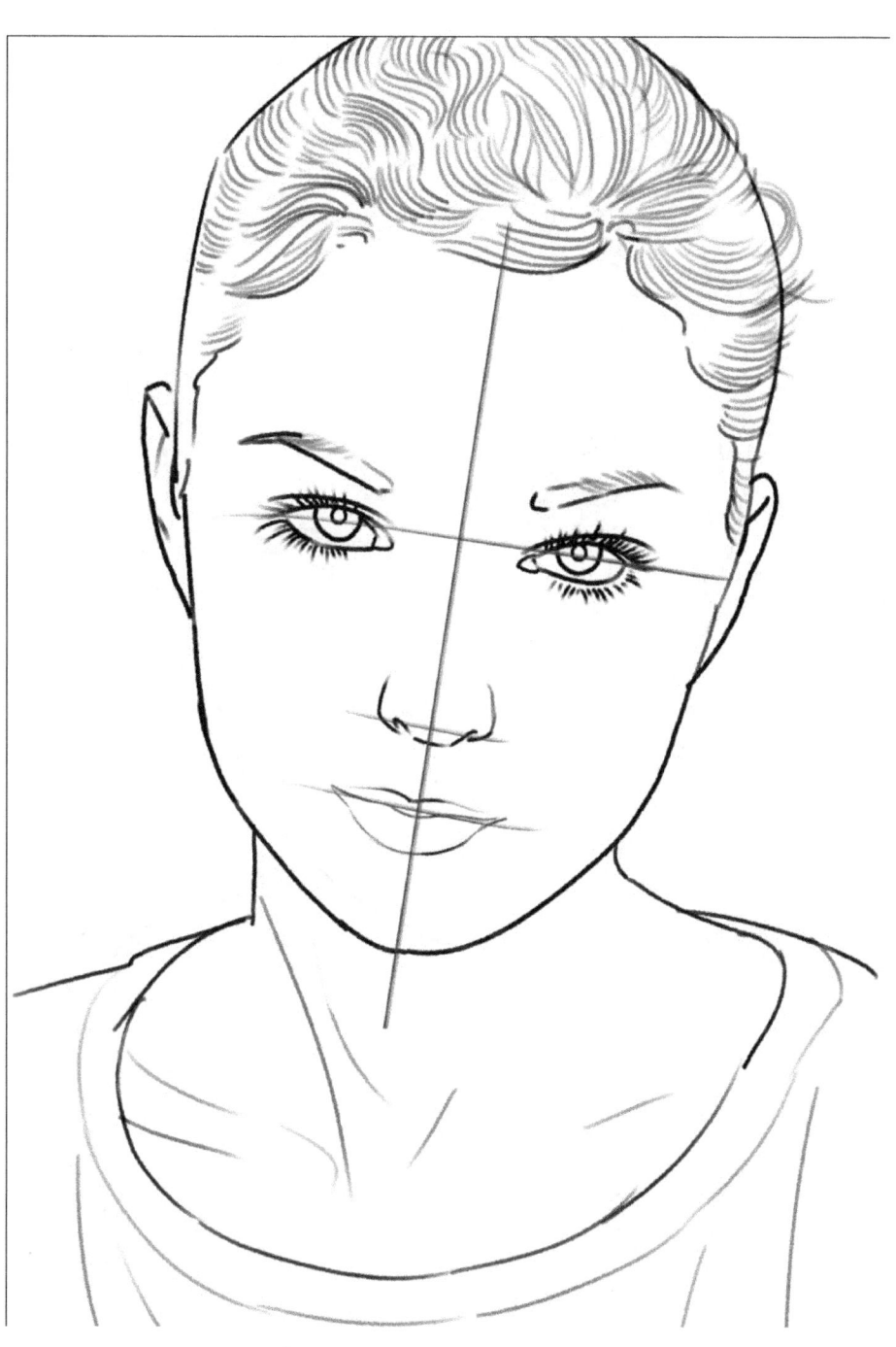

Step 5
Remove the vertical and horizontal lines that were meant for the placement of facial features.

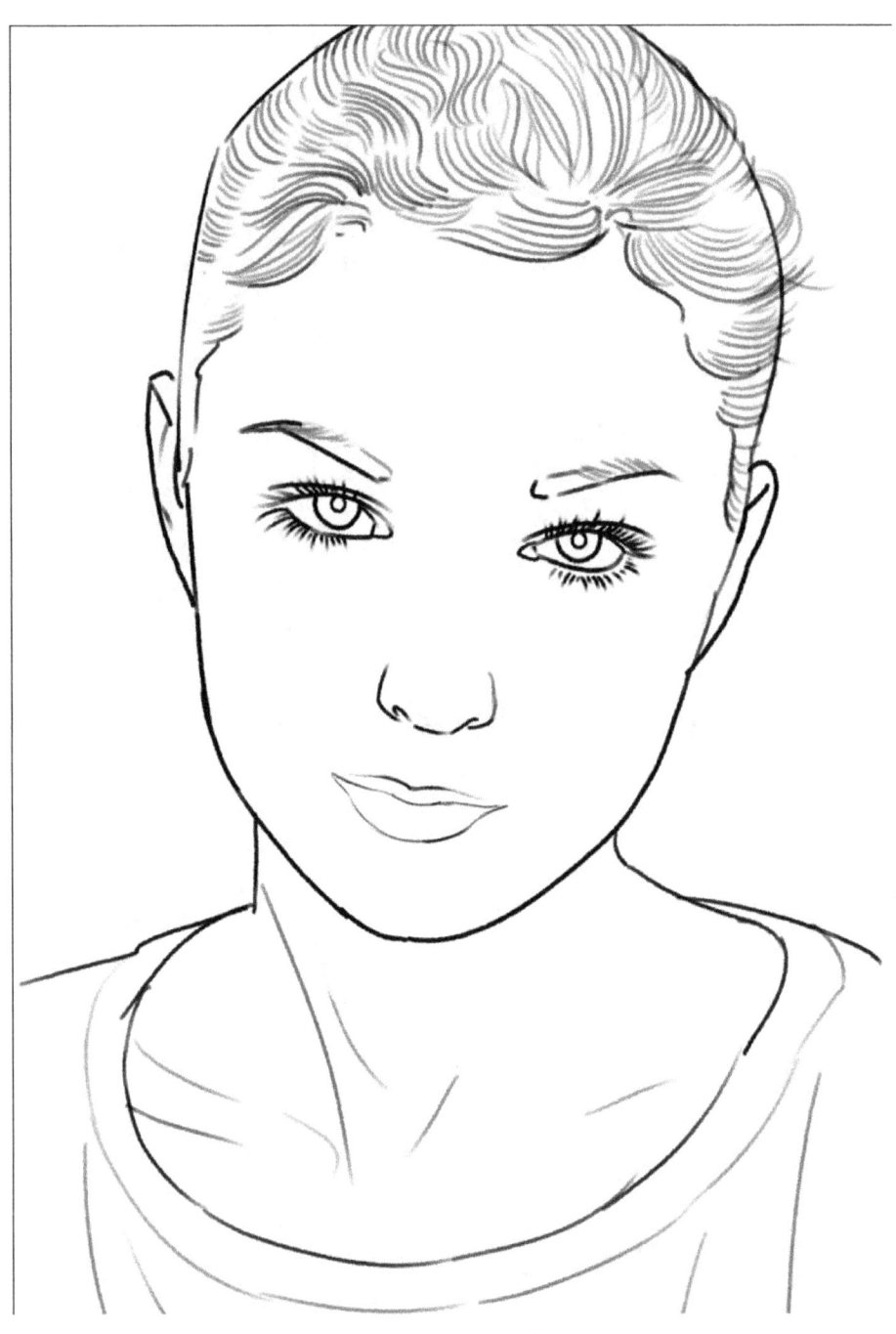

Step 6
Start giving shading in her hairs. Begin with a lighter layer of charcoal shading.

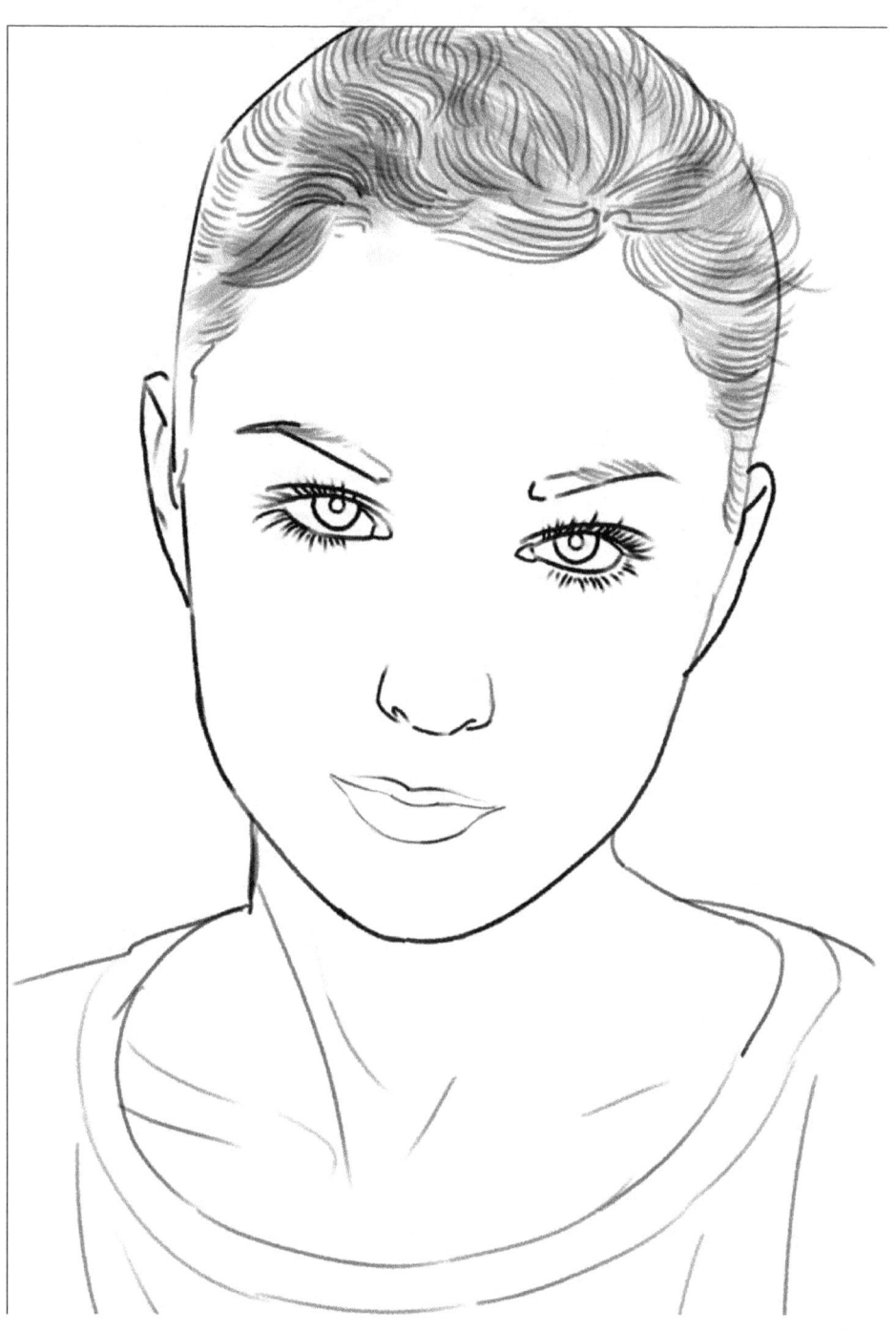

Step 7
Now, give darker shading in some areas of the hairs.

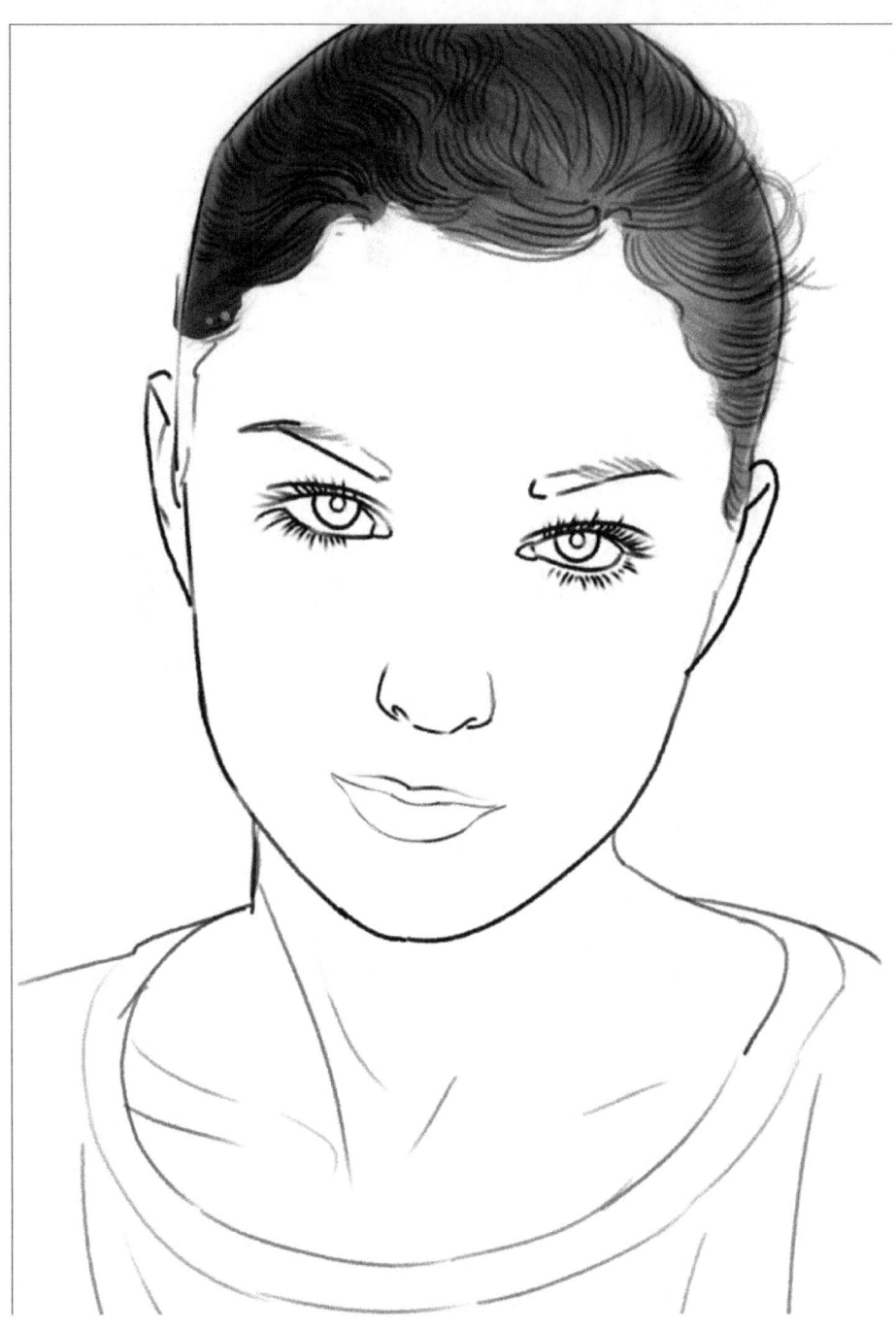

Step 8
Give shading in her eyes, eyebrows, and lips.

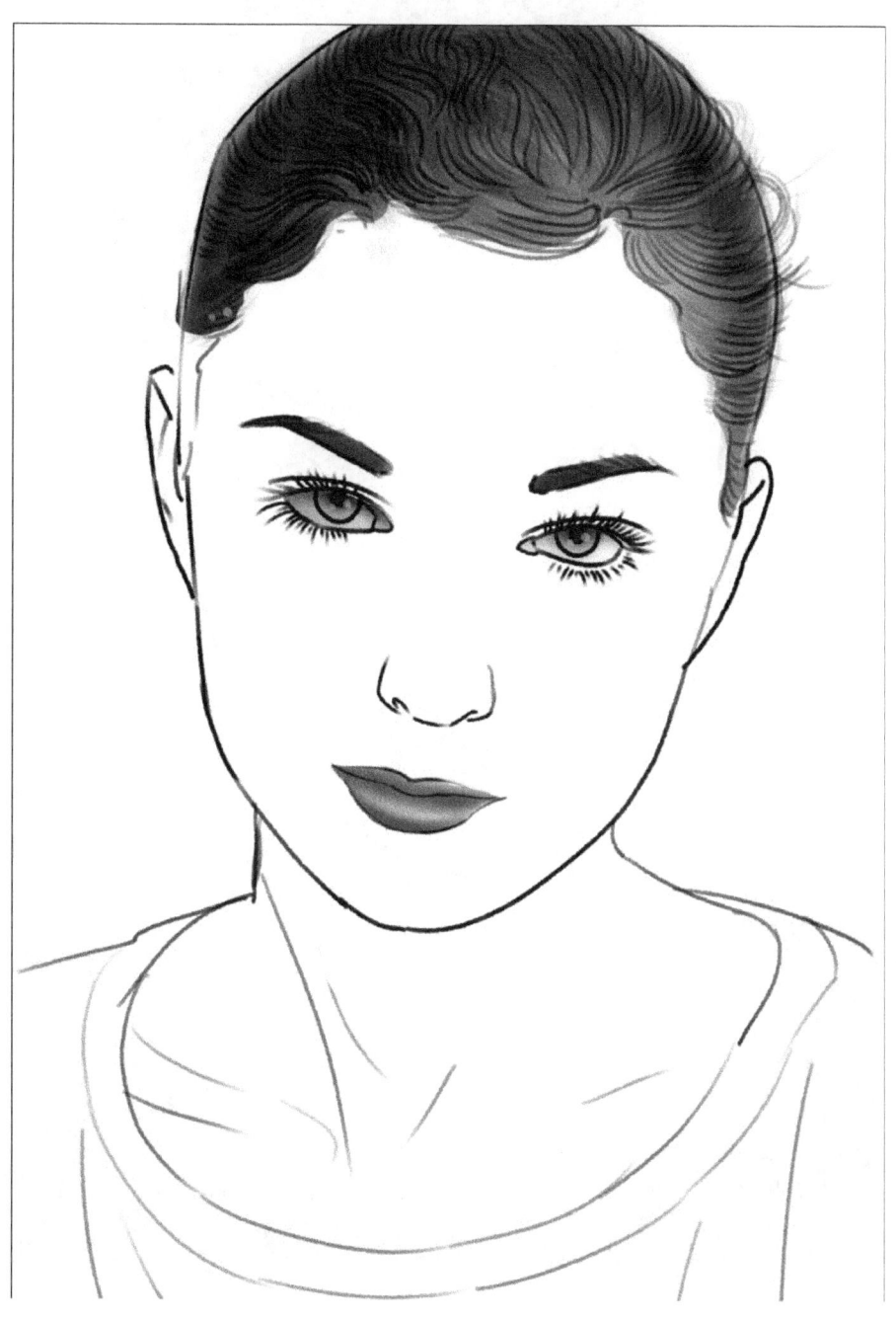

Step 9
Give shading in her clothing.

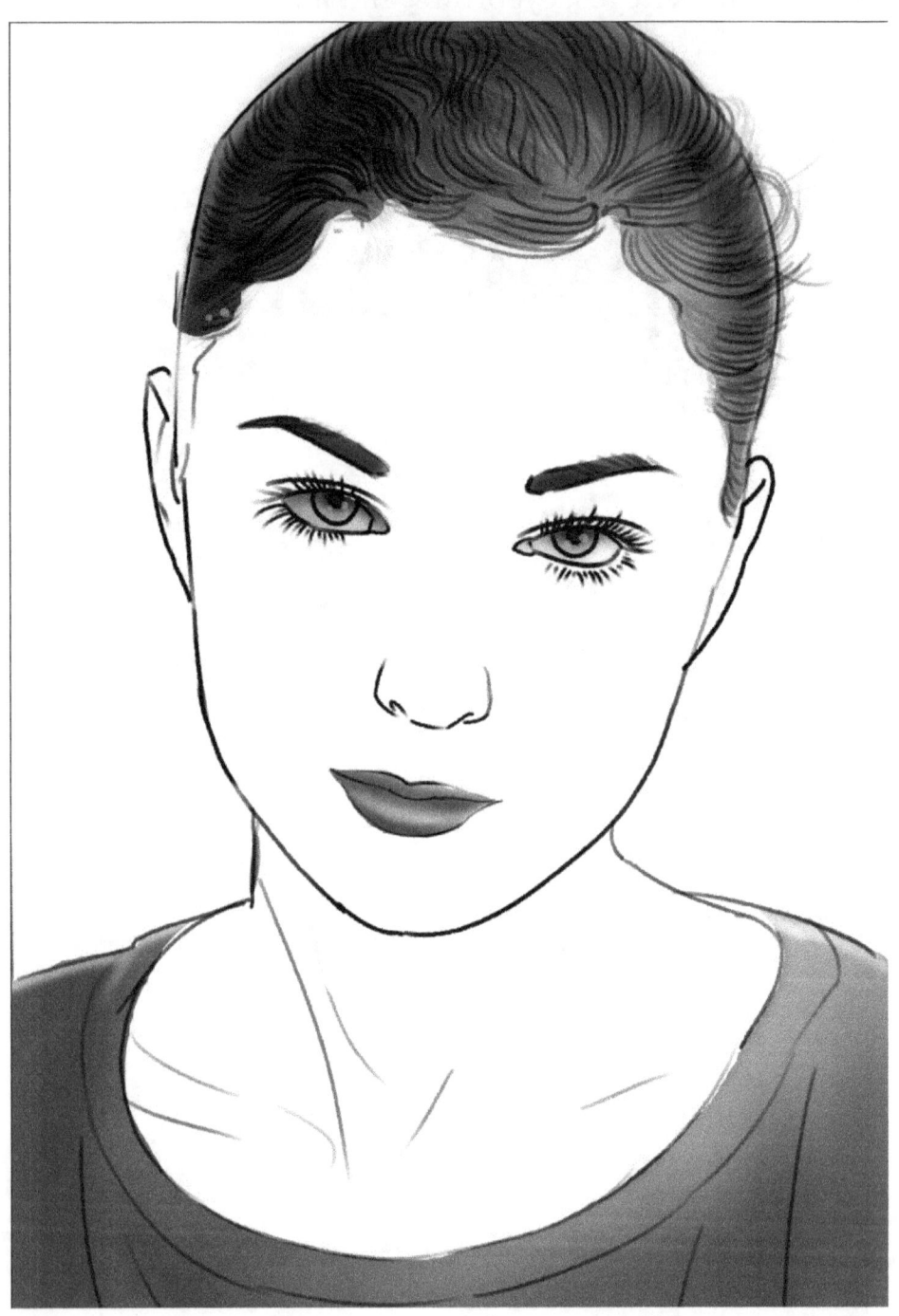

Step 10
Give shading in the neck of Christy.

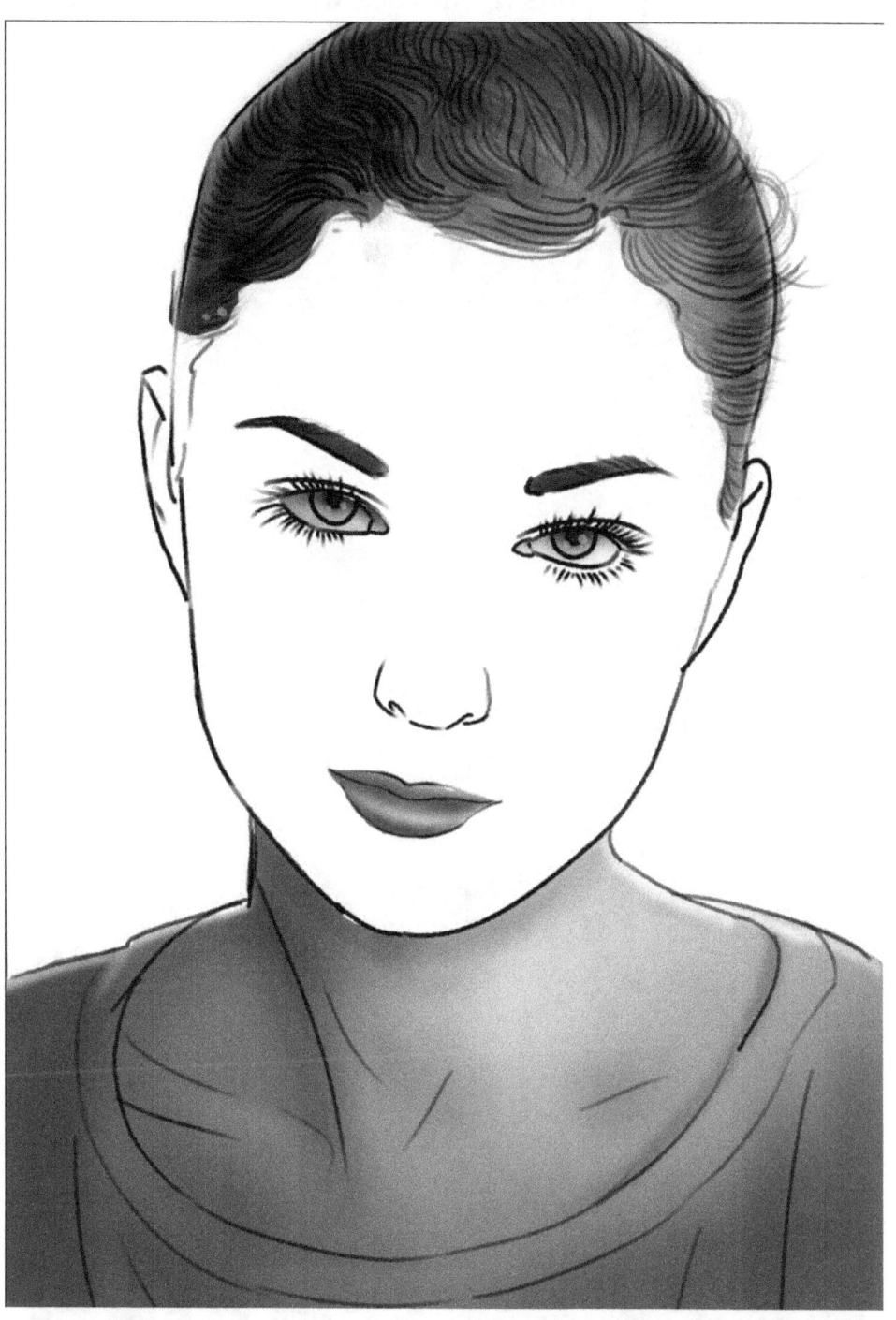

Step 11

Give shading with gradations in her face. Notice that there are darker and lighter portions in the face wherever there are bulges and other changes in the shape of face.

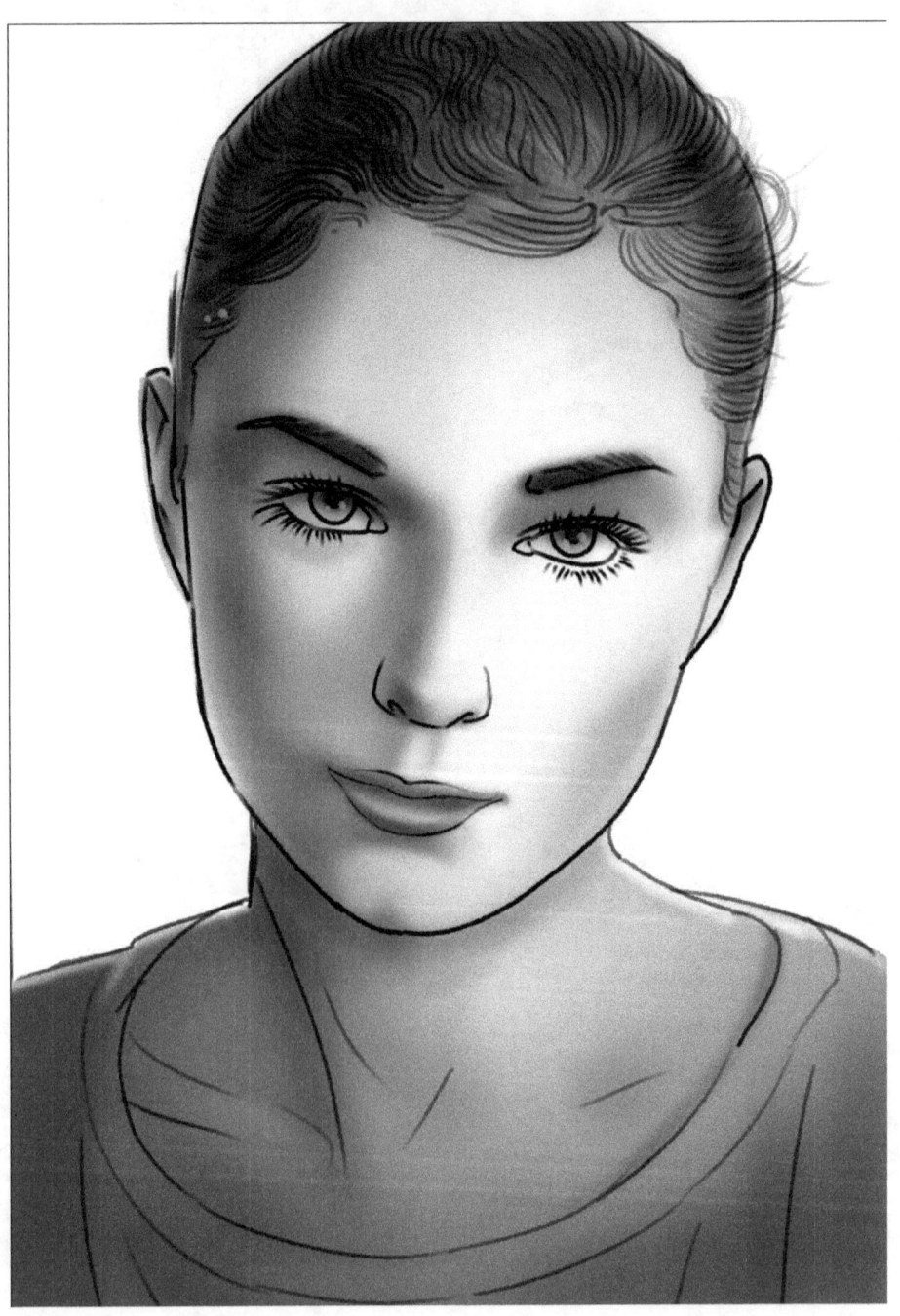

Step 12
To enhance the look of the portrait, give a flat black background in the illustration.

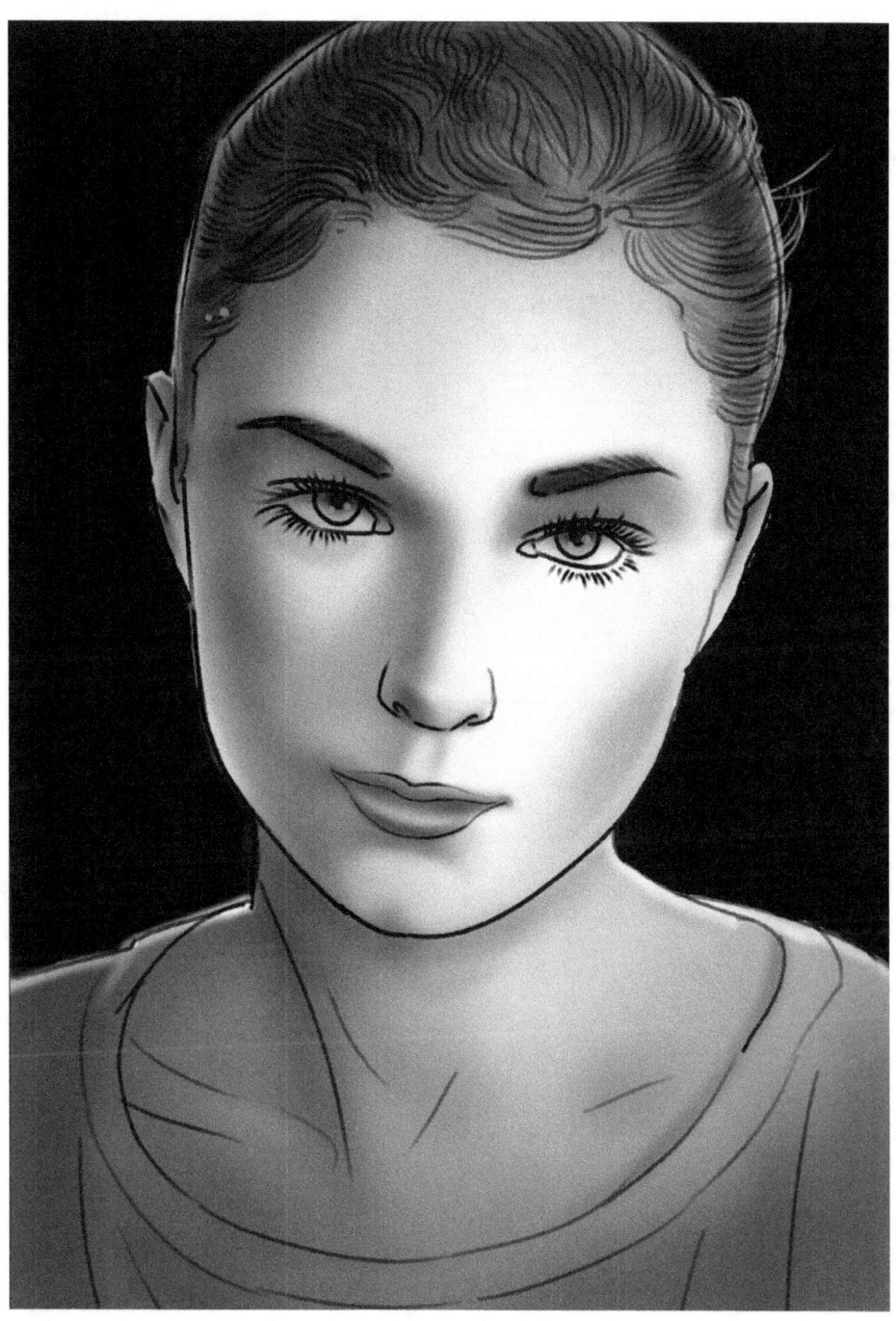

Chapter 5
Portrait of Francesca (female)

Step 1

Draw the basic outline of the face of Francesca. She has a unique hairstyle, with longer hairs on the left side and very sleek hairs on the left.

Draw the vertical and horizontal lines that are meant for the placement of facial features.

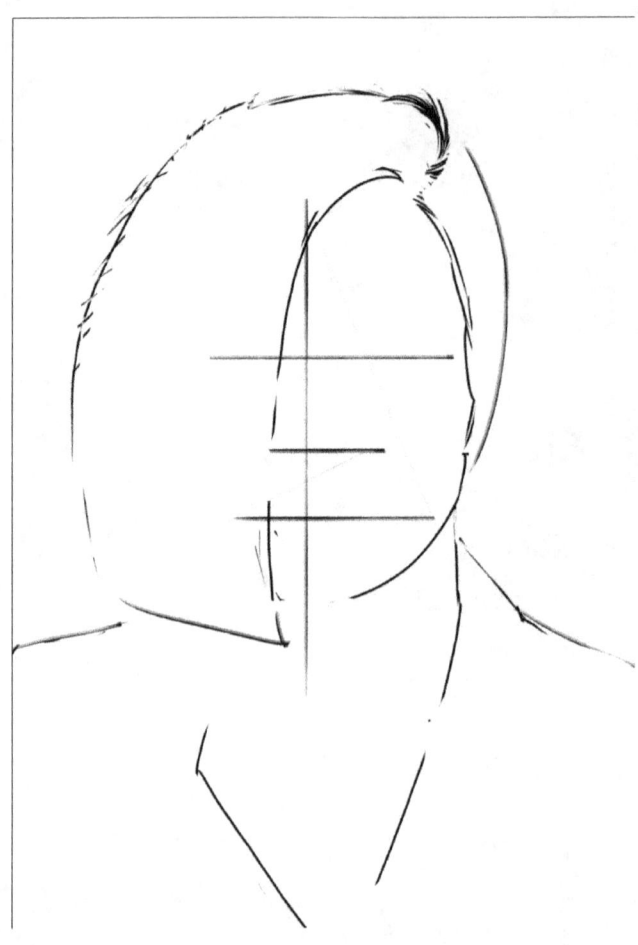

Step 2
Give details of strands of her hairs. The longer hairs are falling on the left side of the face and do not fall in many directions. The shorter hairs on the right side of the face are protruding in different directions.

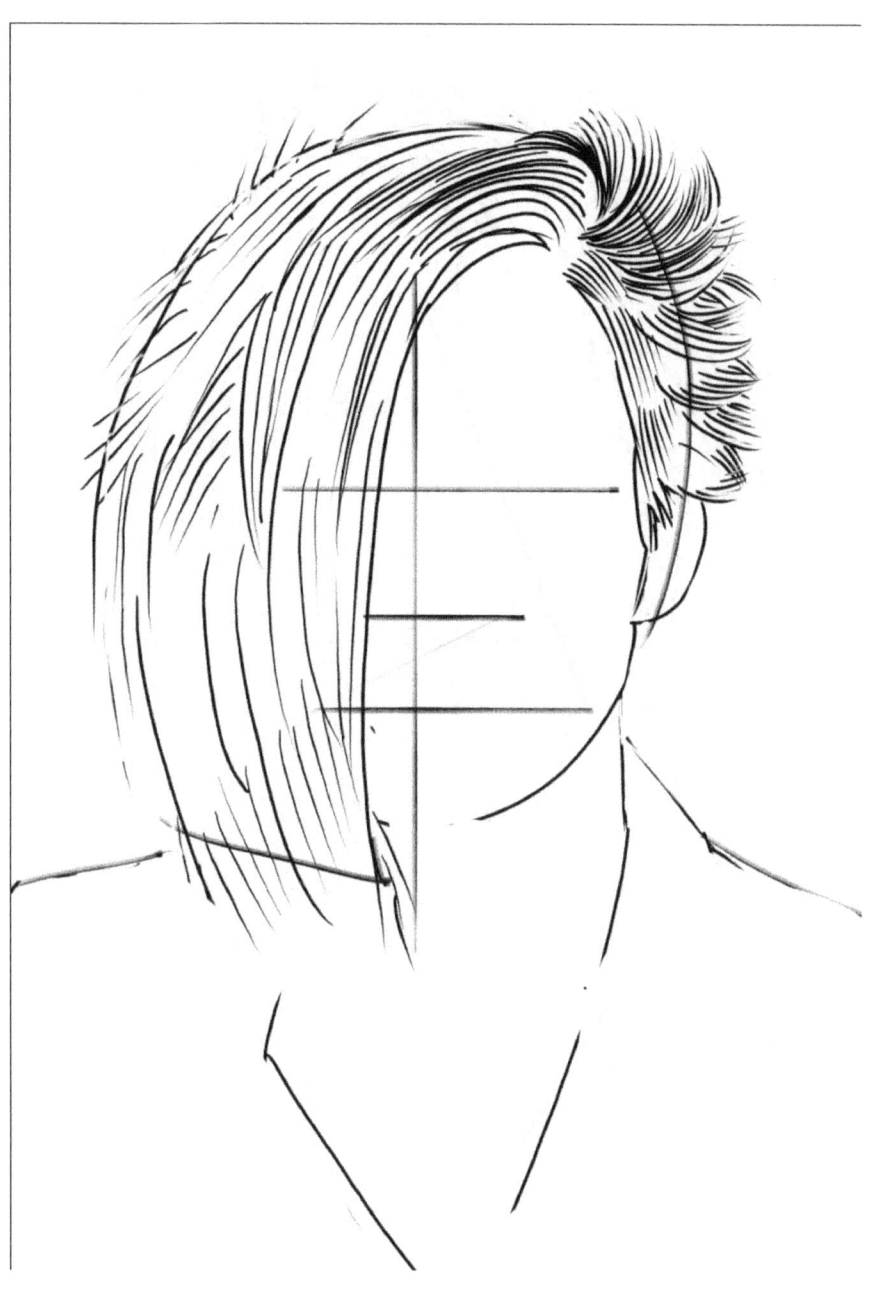

Step 3
Draw the right eye that is visible, and the mouth that displays a few teeth.

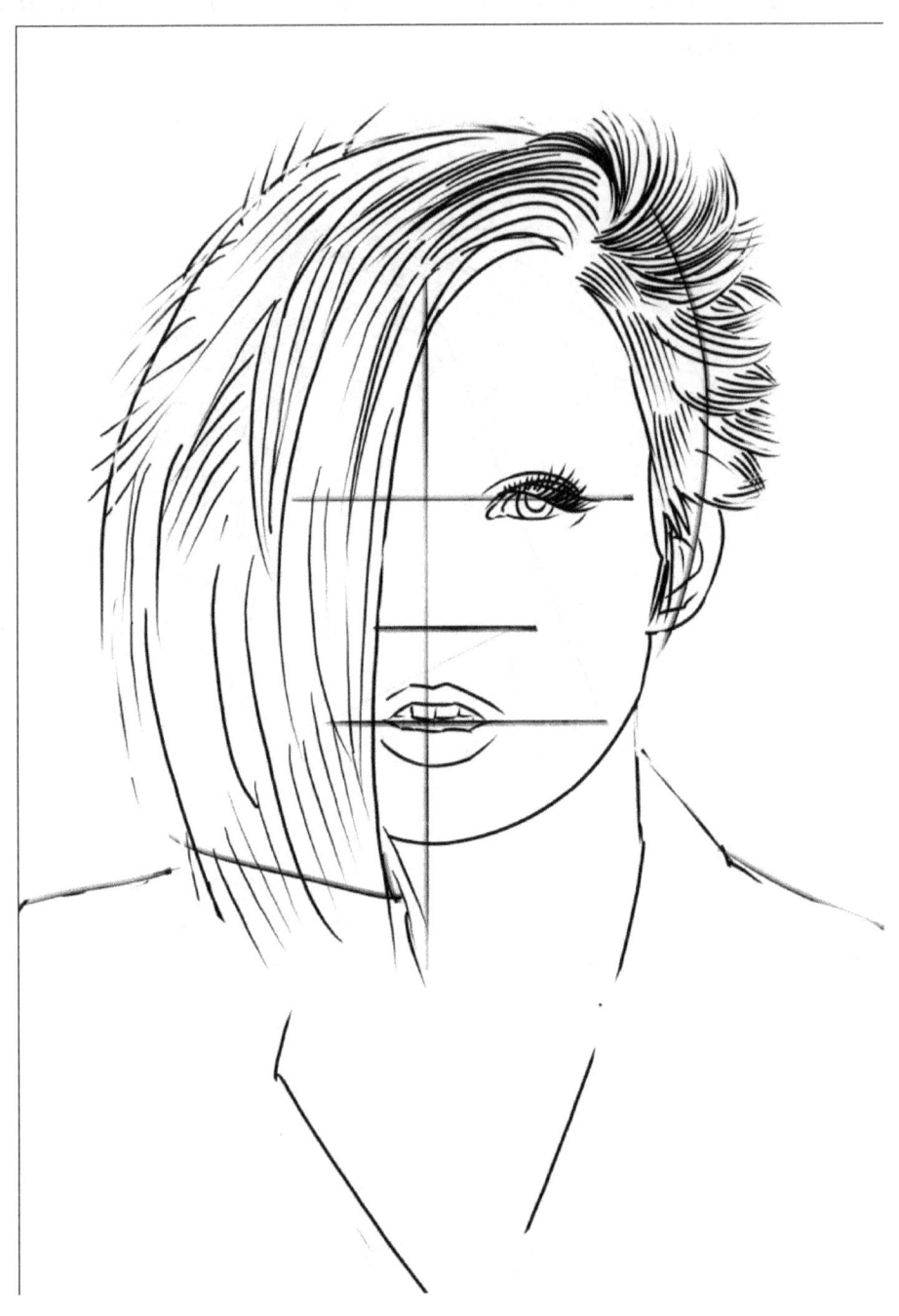

Step 4

Give a few details to her clothing. Francesca has a few rivets placed on her shirt's shoulder.

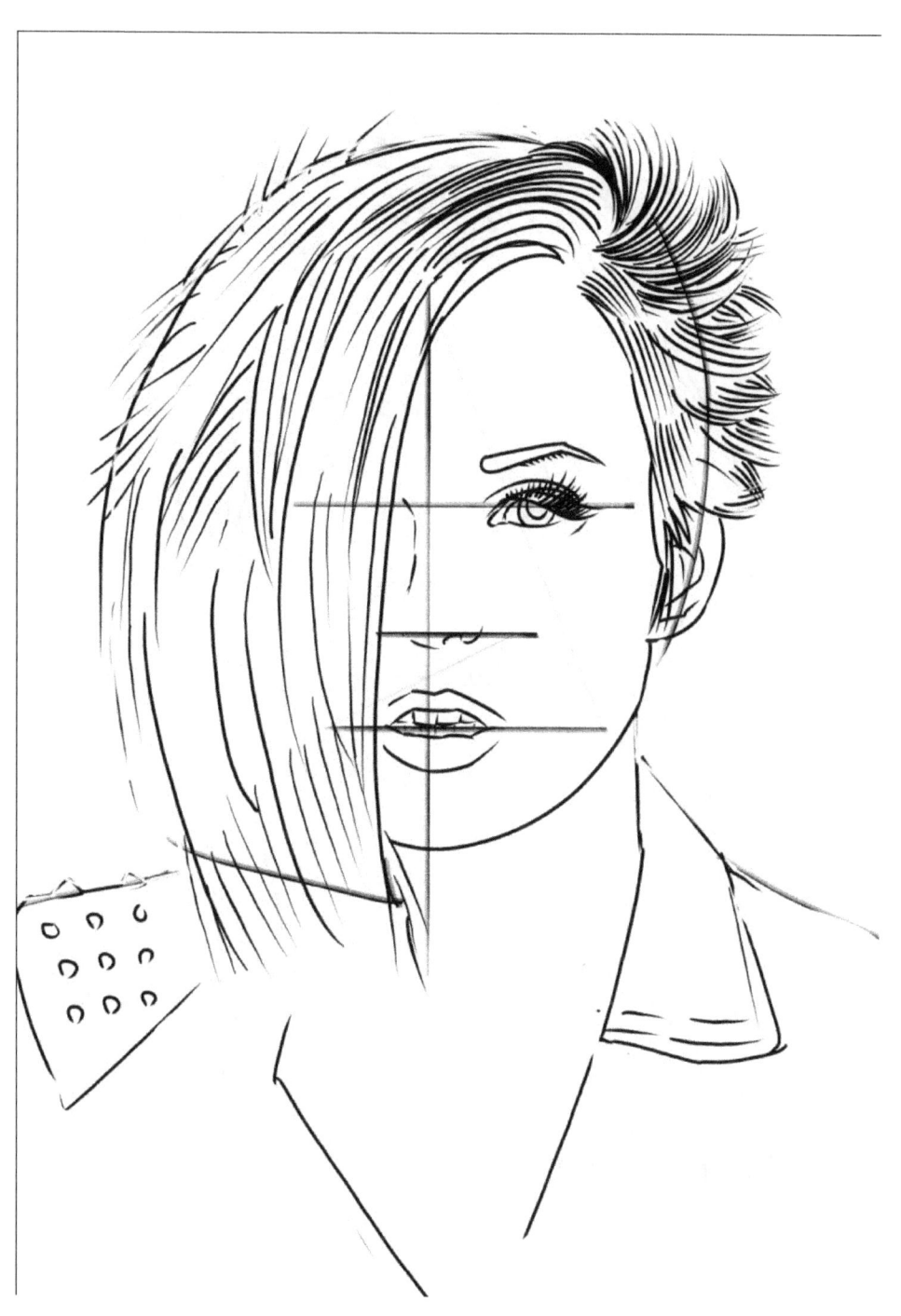

Step 5
Give more details to her clothing as shown in the illustration.

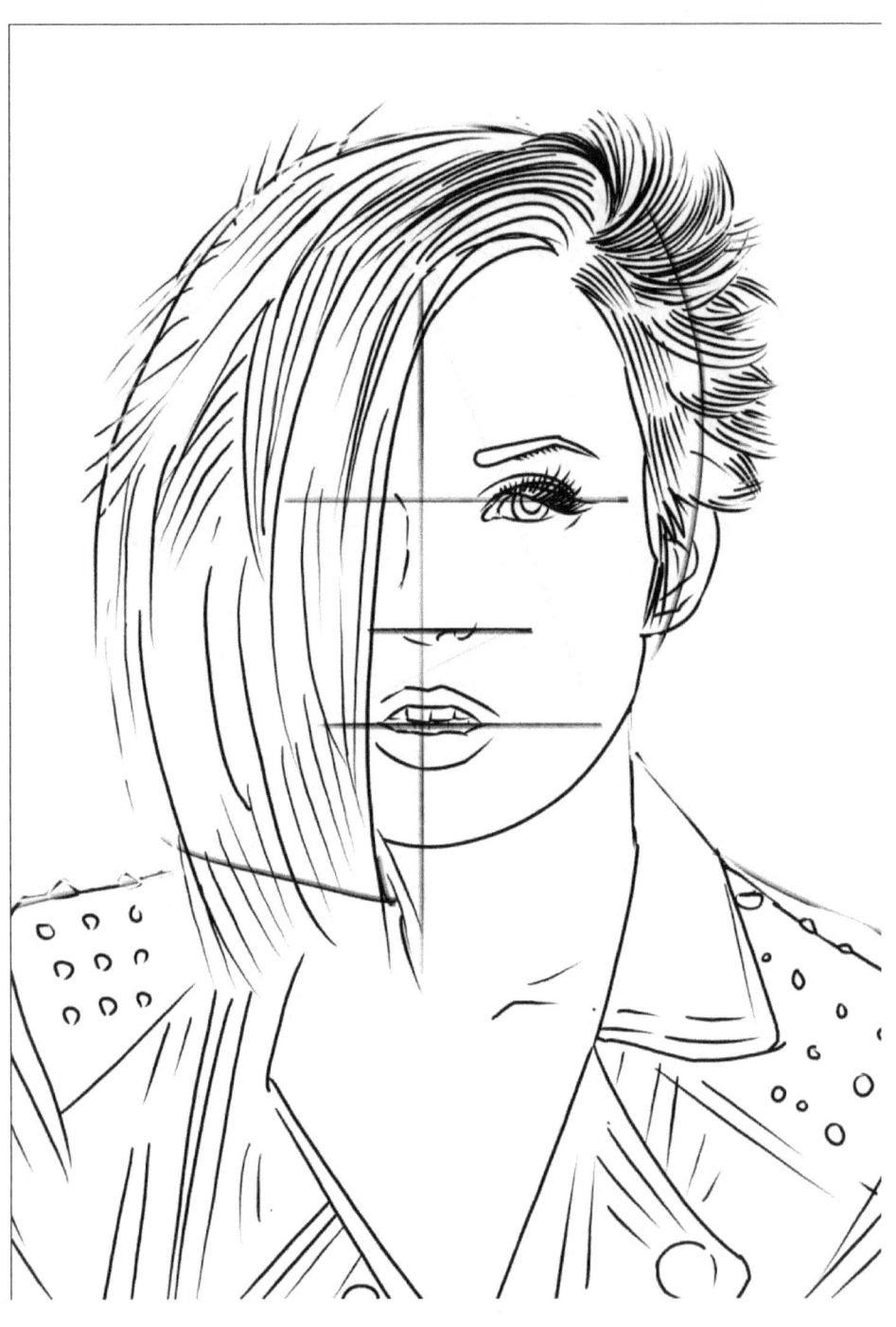

Step 6
Remove the vertical and horizontal lines that were meant for the placement of facial features.

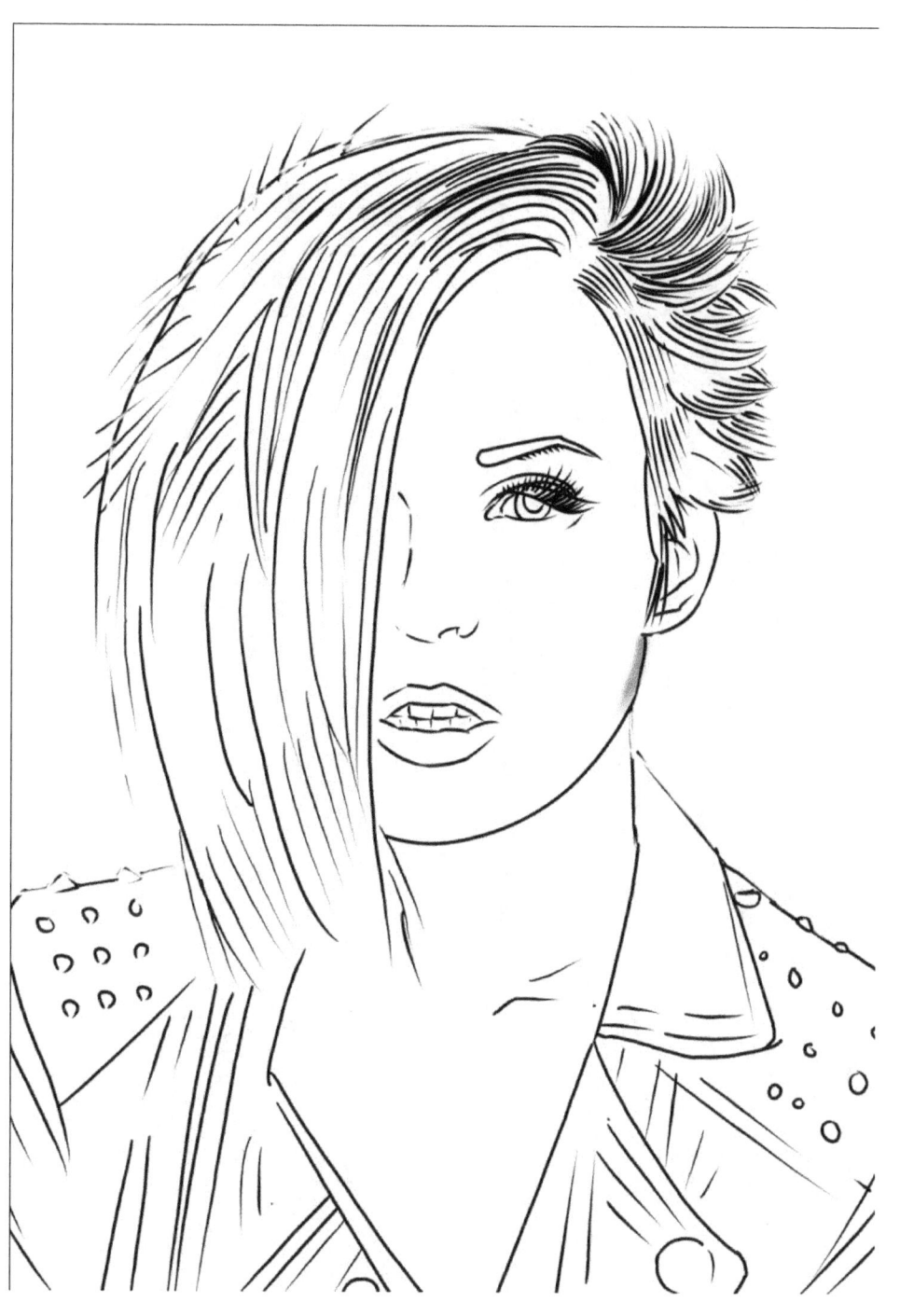

Step 7

Give shading in her face. Notice the gradations in the face because of the tonal values. Give shading in the eyebrow that is visible from her hairs.

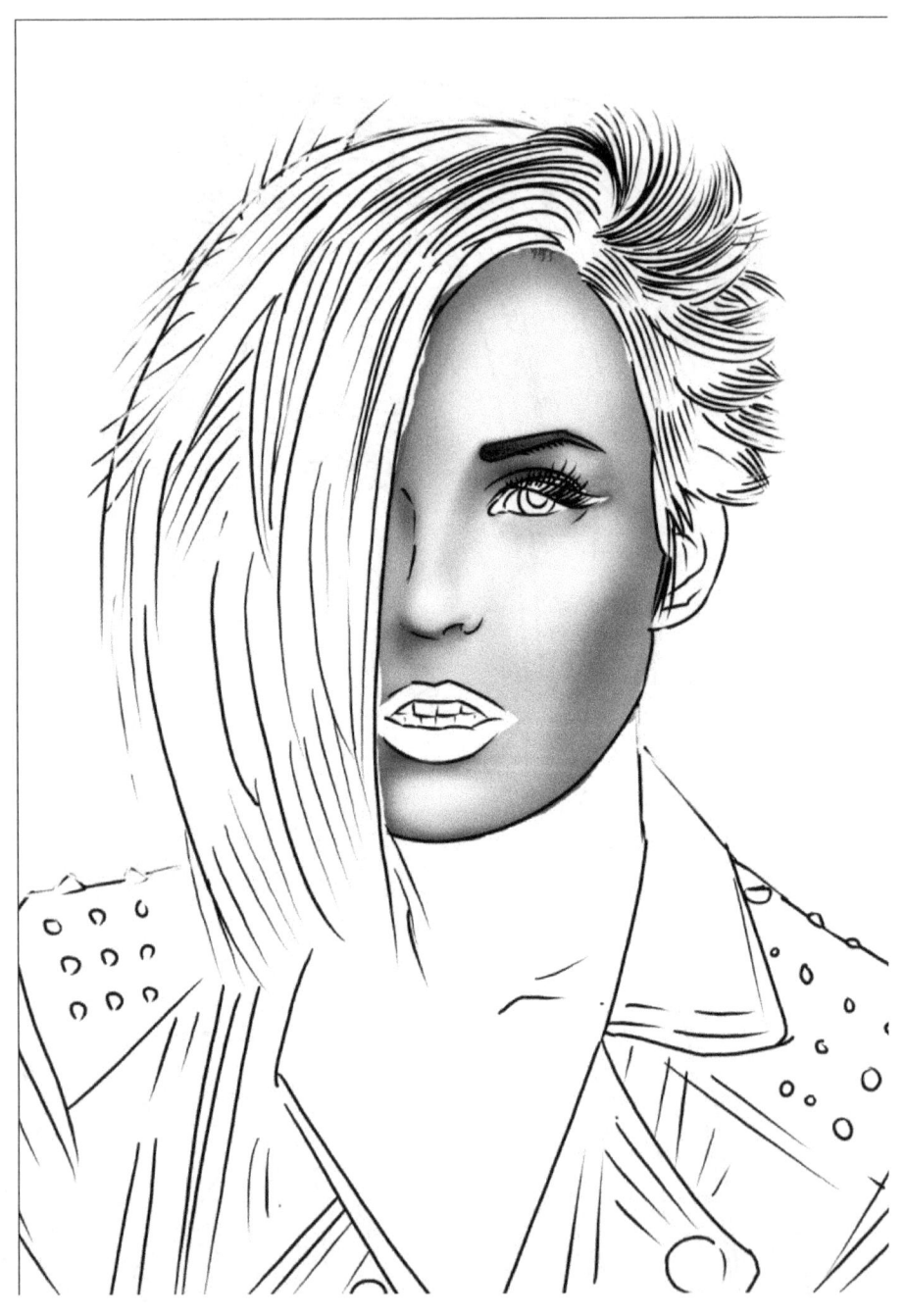

Step 8
Give shading in her eye and enhance her nose.

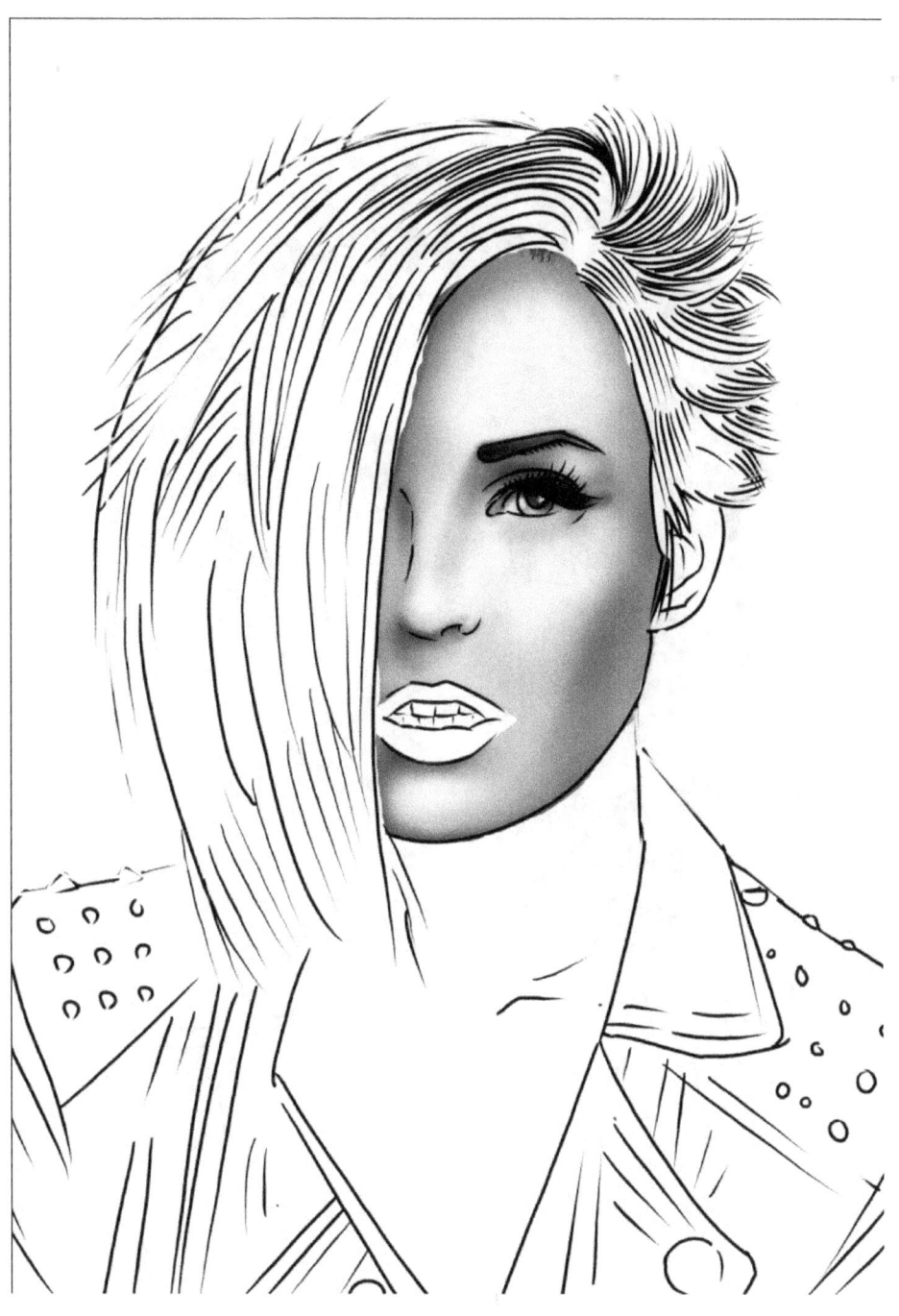

Step 9
Give shading in her hairs.

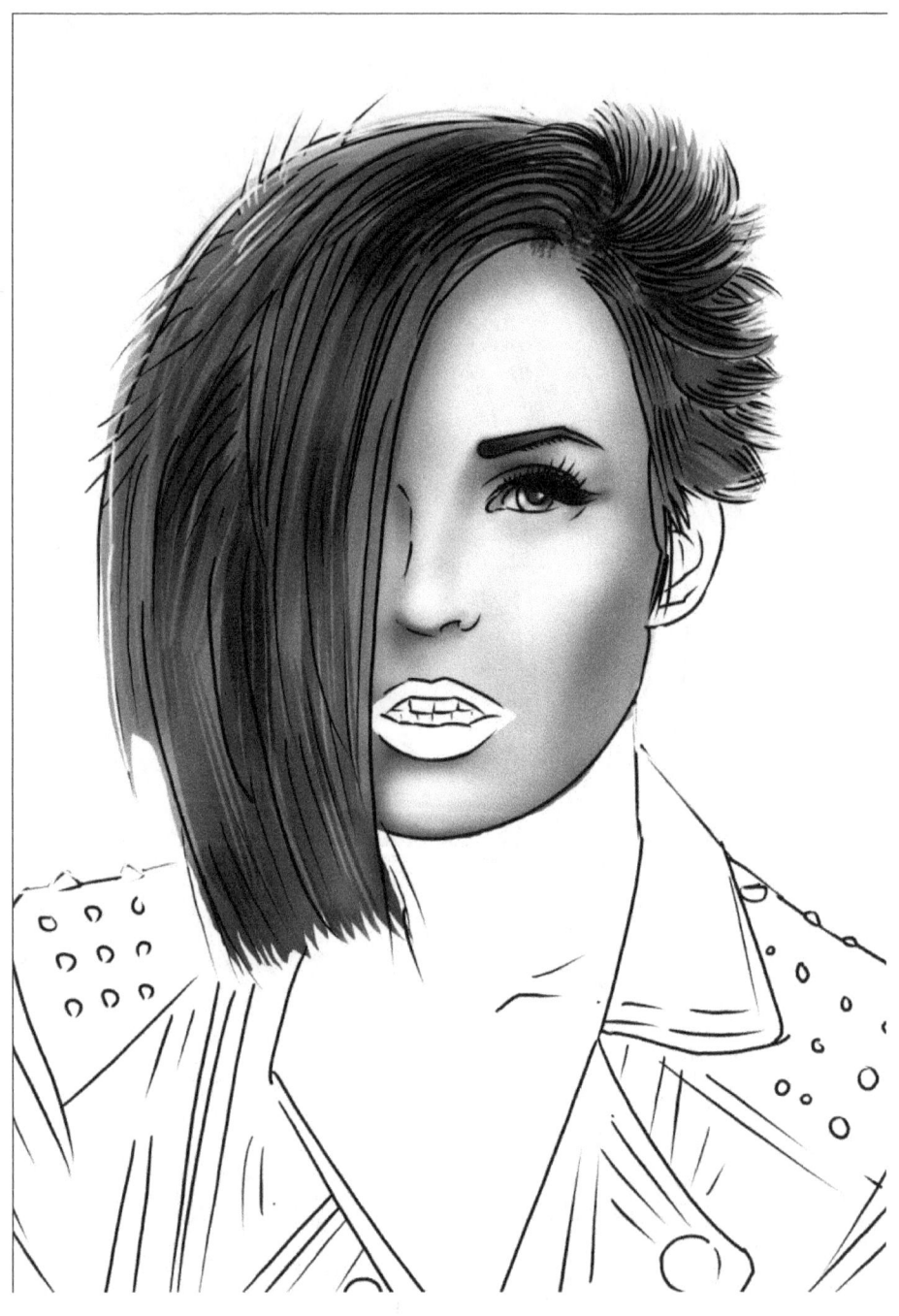

Step 10
Give shading in her neck.

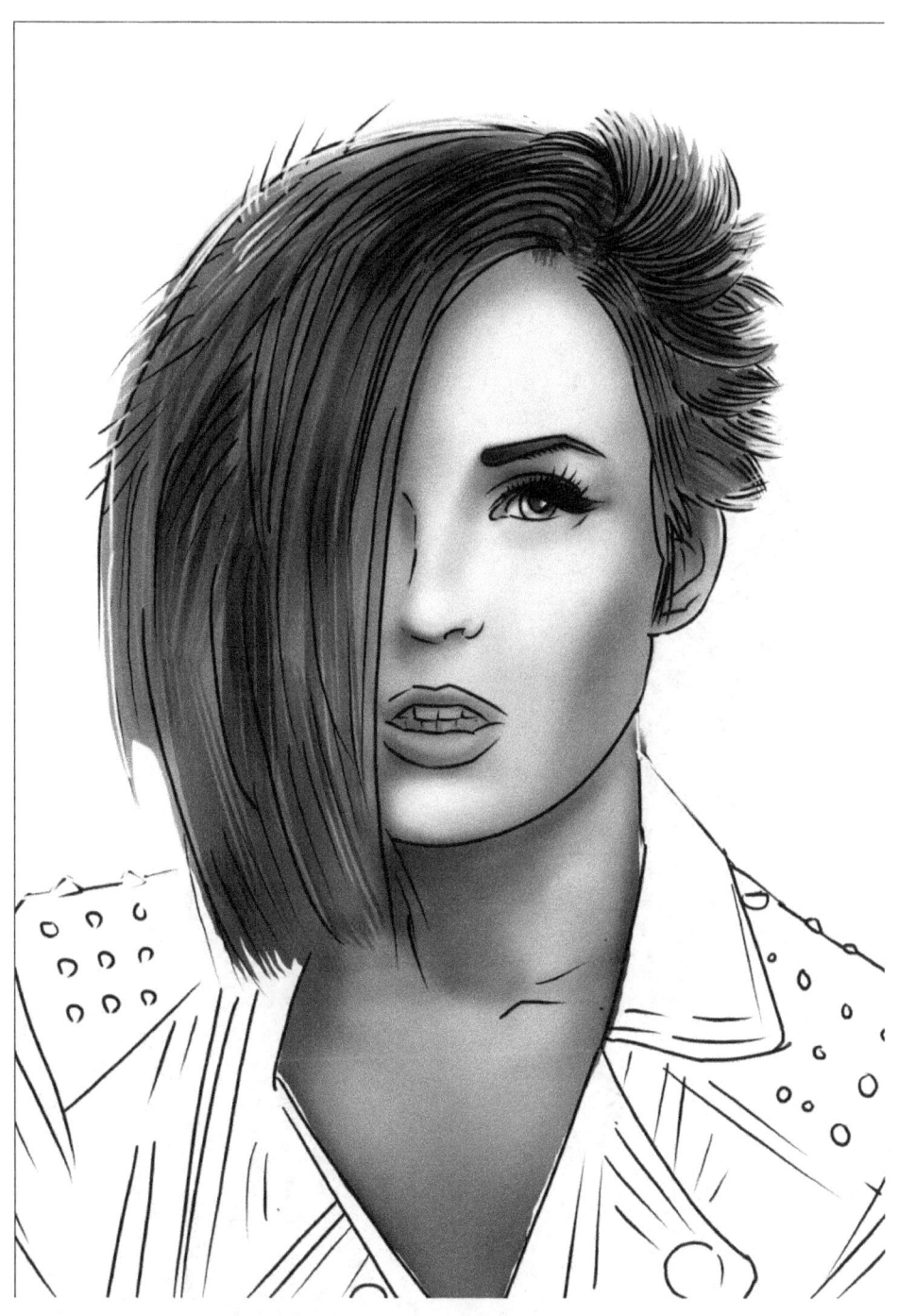

Step 11
Start giving in her clothing. Give shading in the right portion of her shirt.

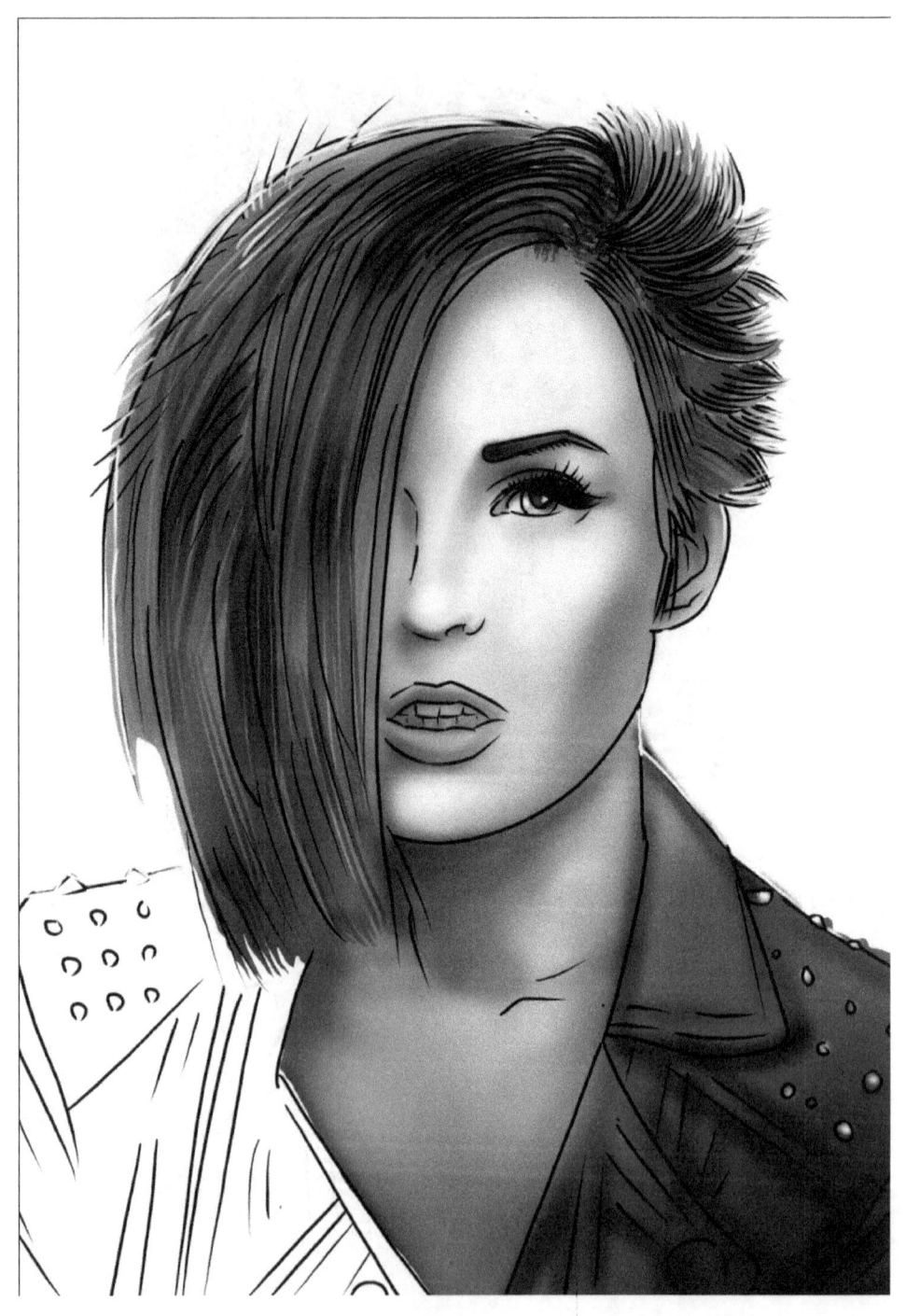

Step 12
Complete the shading in her shirt.

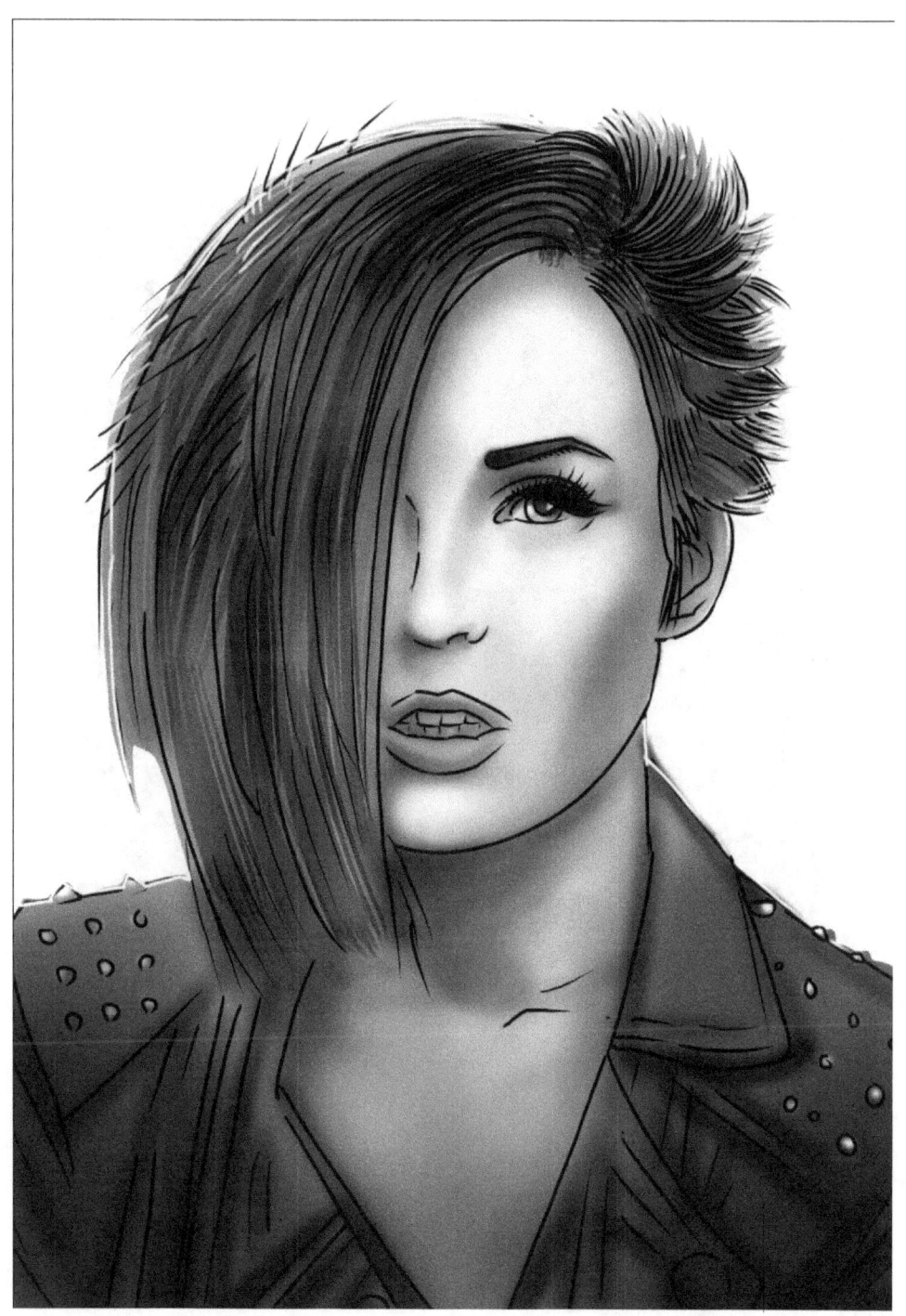

Step 13

To enhance the portrait, give a black background. Give a white reflection on her hairs' edge so that the portrait is not merged with the background.

The portrait of Francesca is ready.

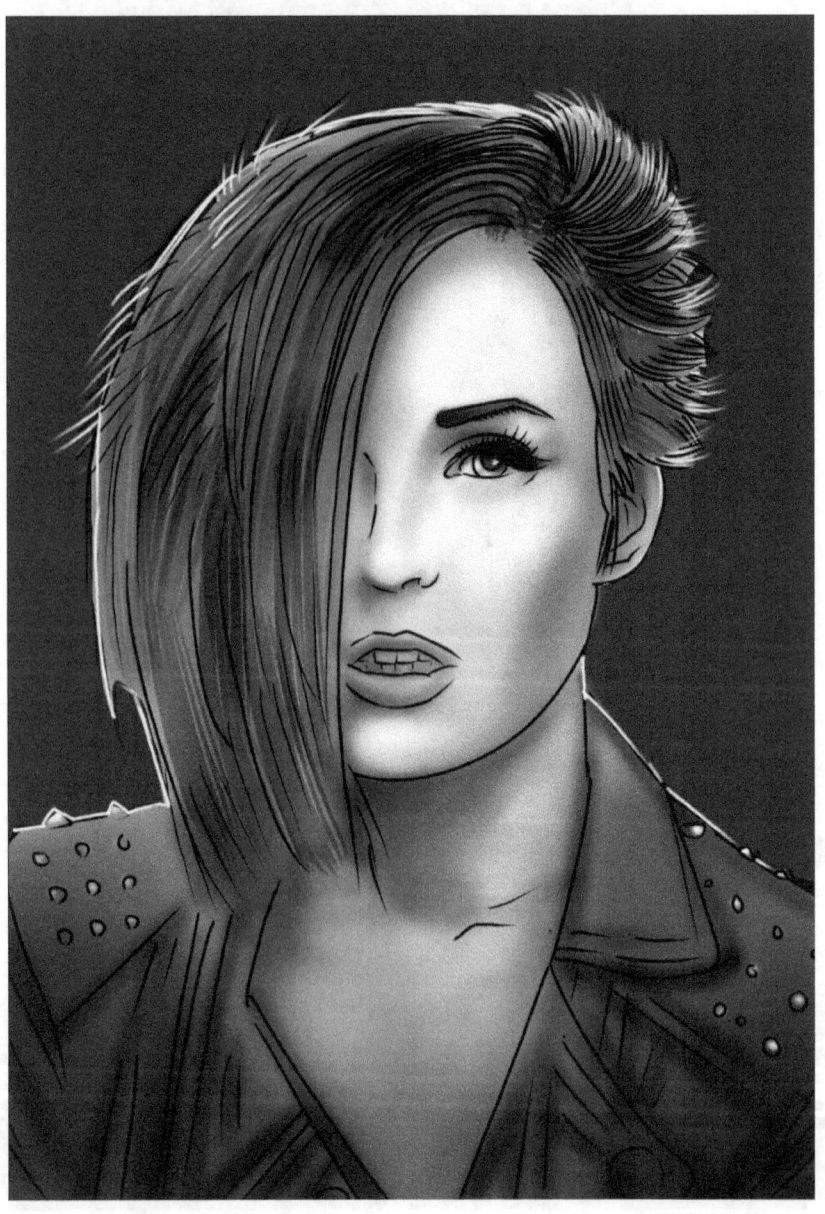

Chapter 6
Portrait of Alexis (male)

Step 1
Draw the basic outline of the face of Alexis. Draw the vertical and horizontal lines that are meant for the placement of facial features.

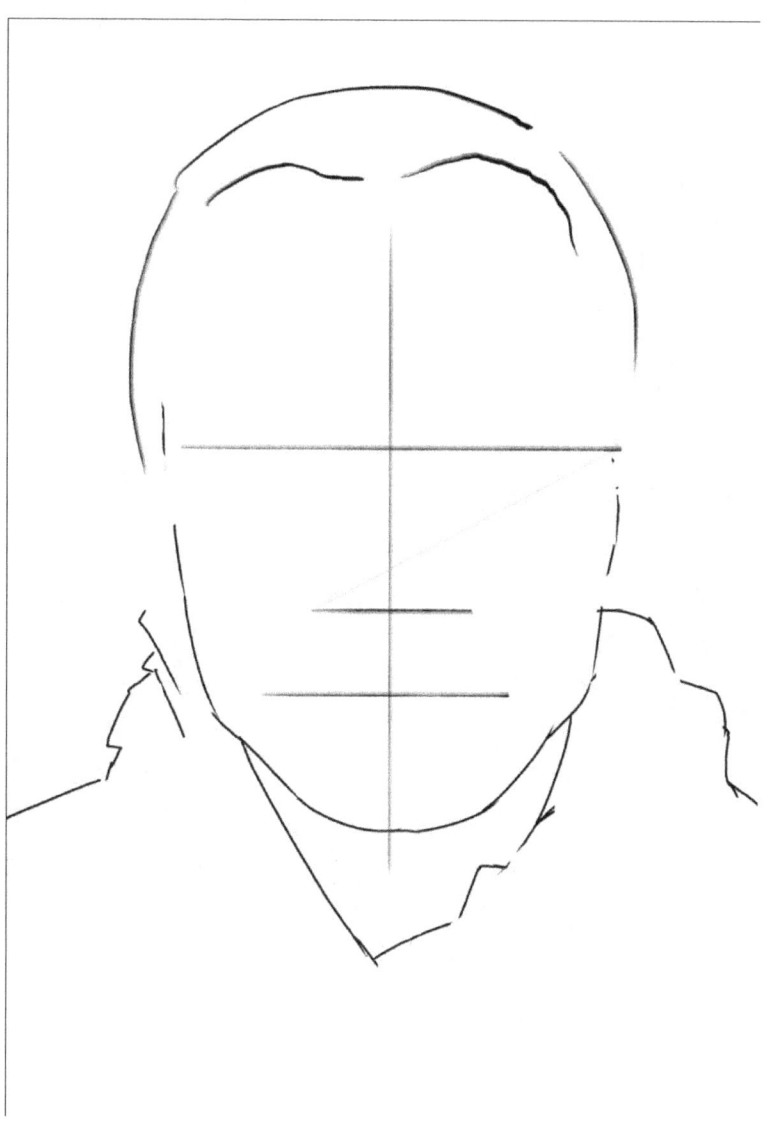

Step 2
Give details of his clothing. He is wearing a high- collared jacket.

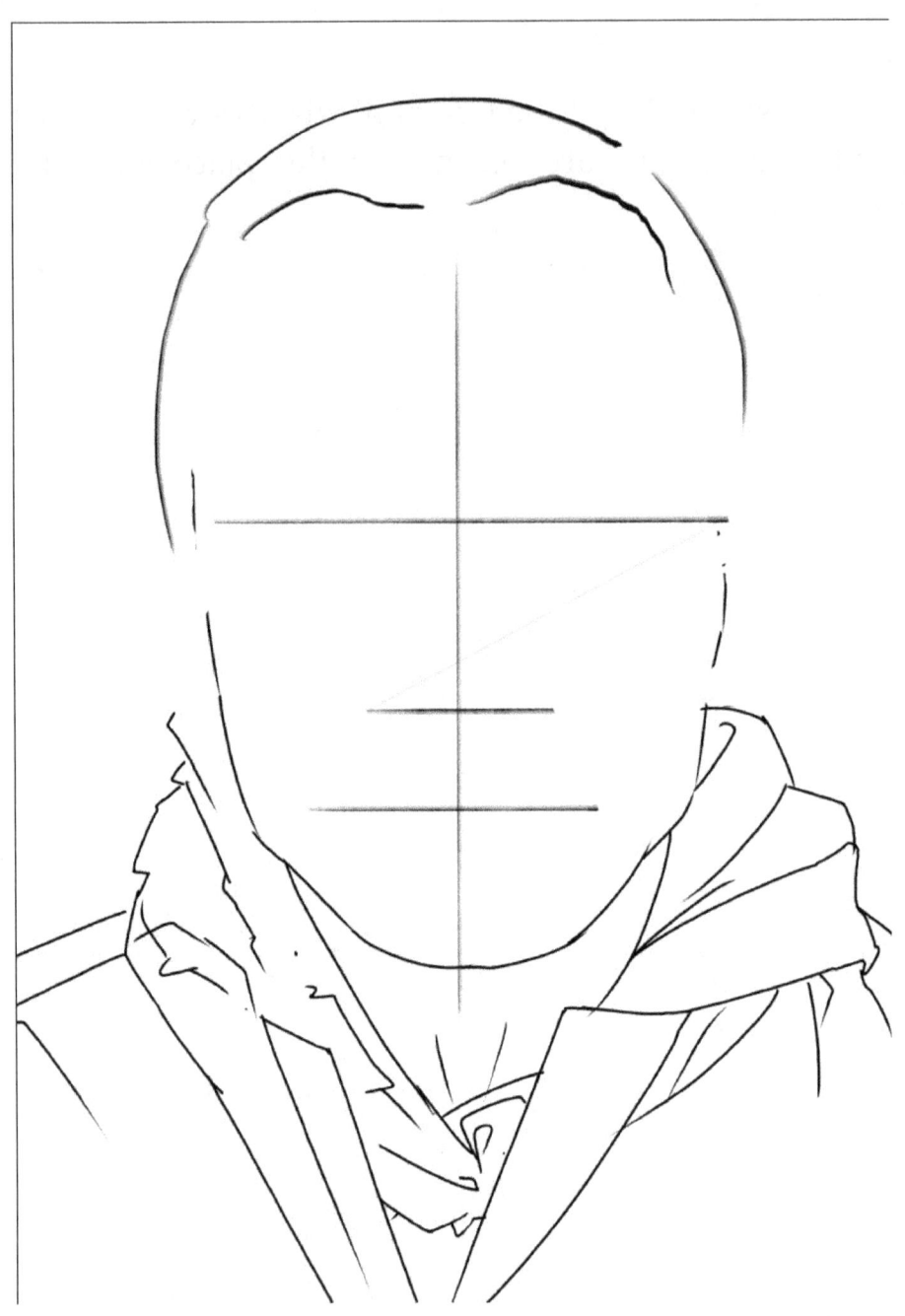

Step 3

Draw the eyebrows of Alexis and some wrinkles on his forehead.

Draw the strands of his hairs. Since his hairs are not very long, you can easily draw his hairs' strands.

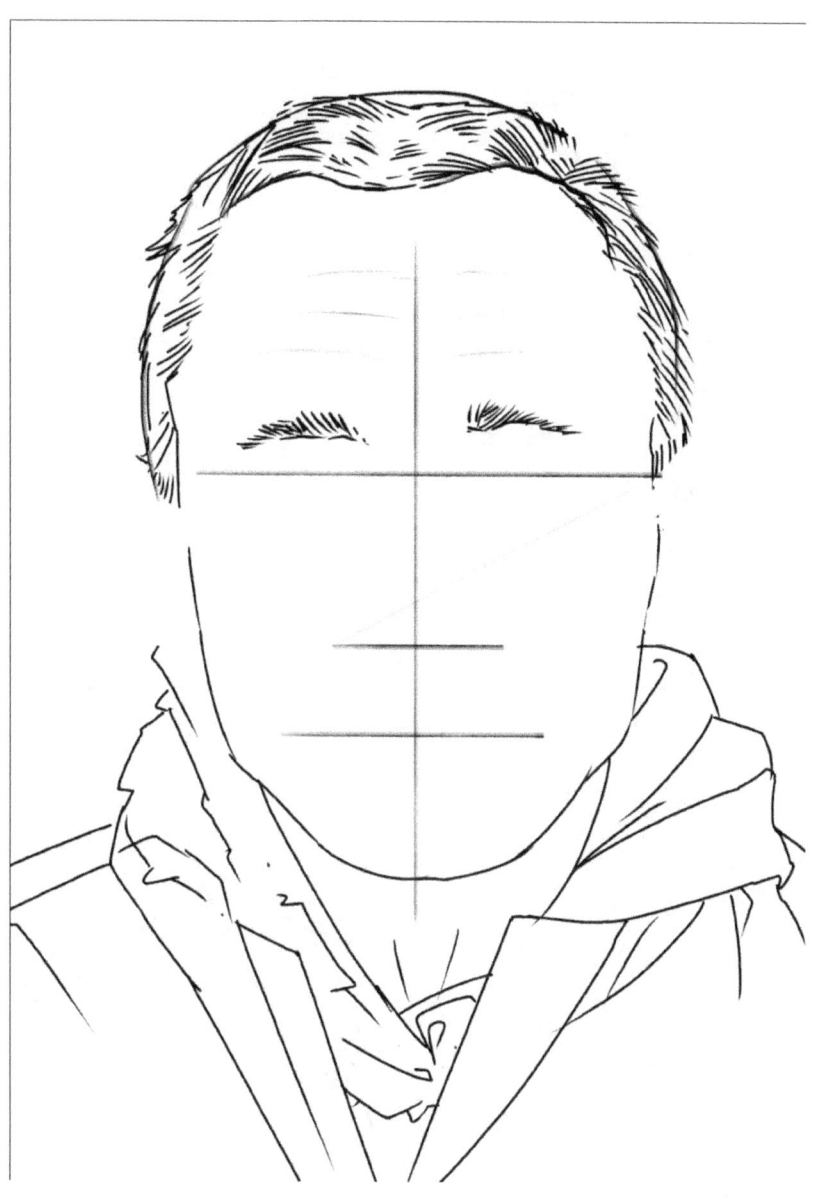

Step 4

Draw his eyes. Since Alexis is a middle-aged man, he has wrinkles on his forehead and his eyes are set a little deep in the eye sockets.

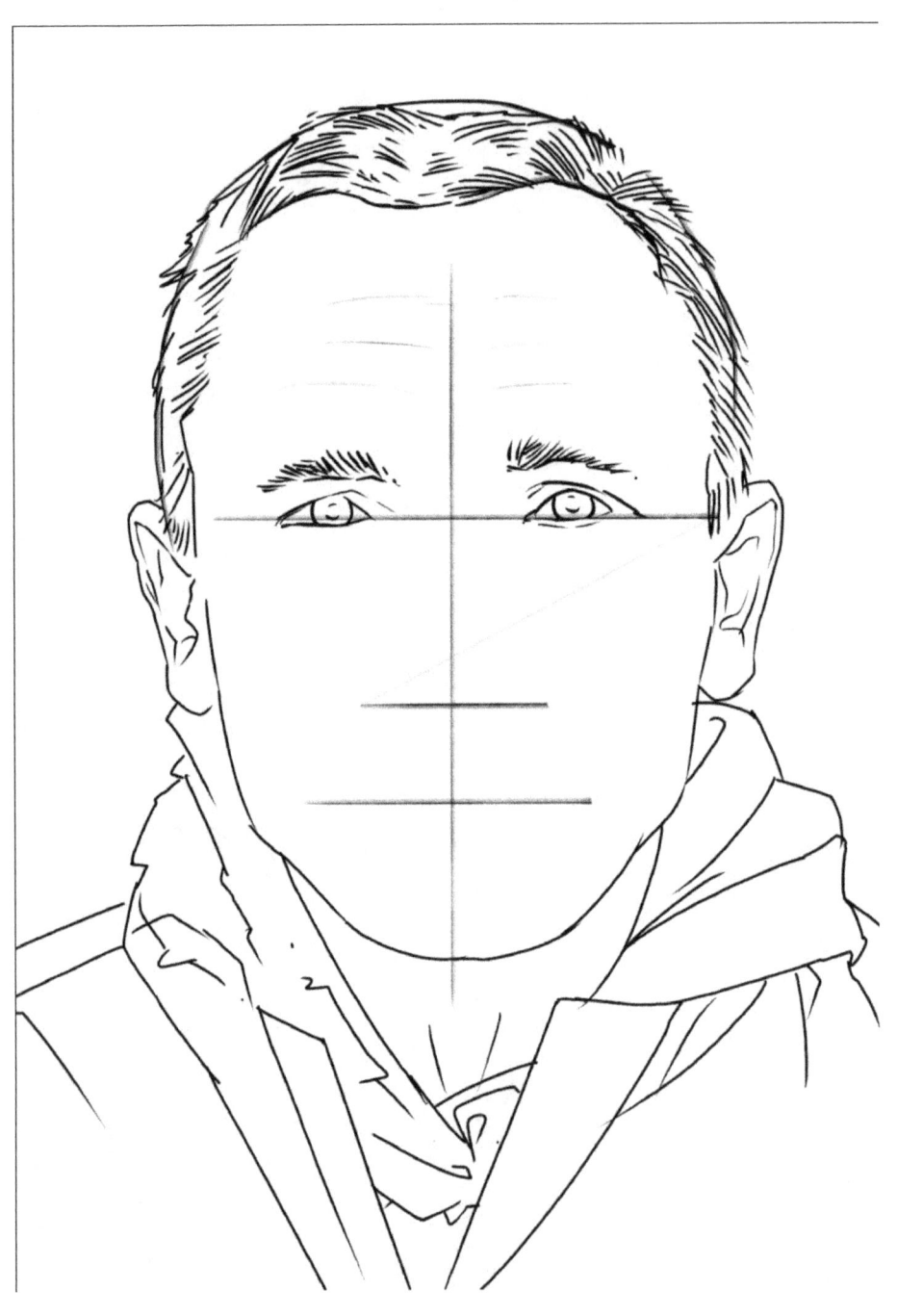

Step 5

Draw his nose and mouth. Notice the lines of his cheek around the nose and mouth, which often occur due to age.

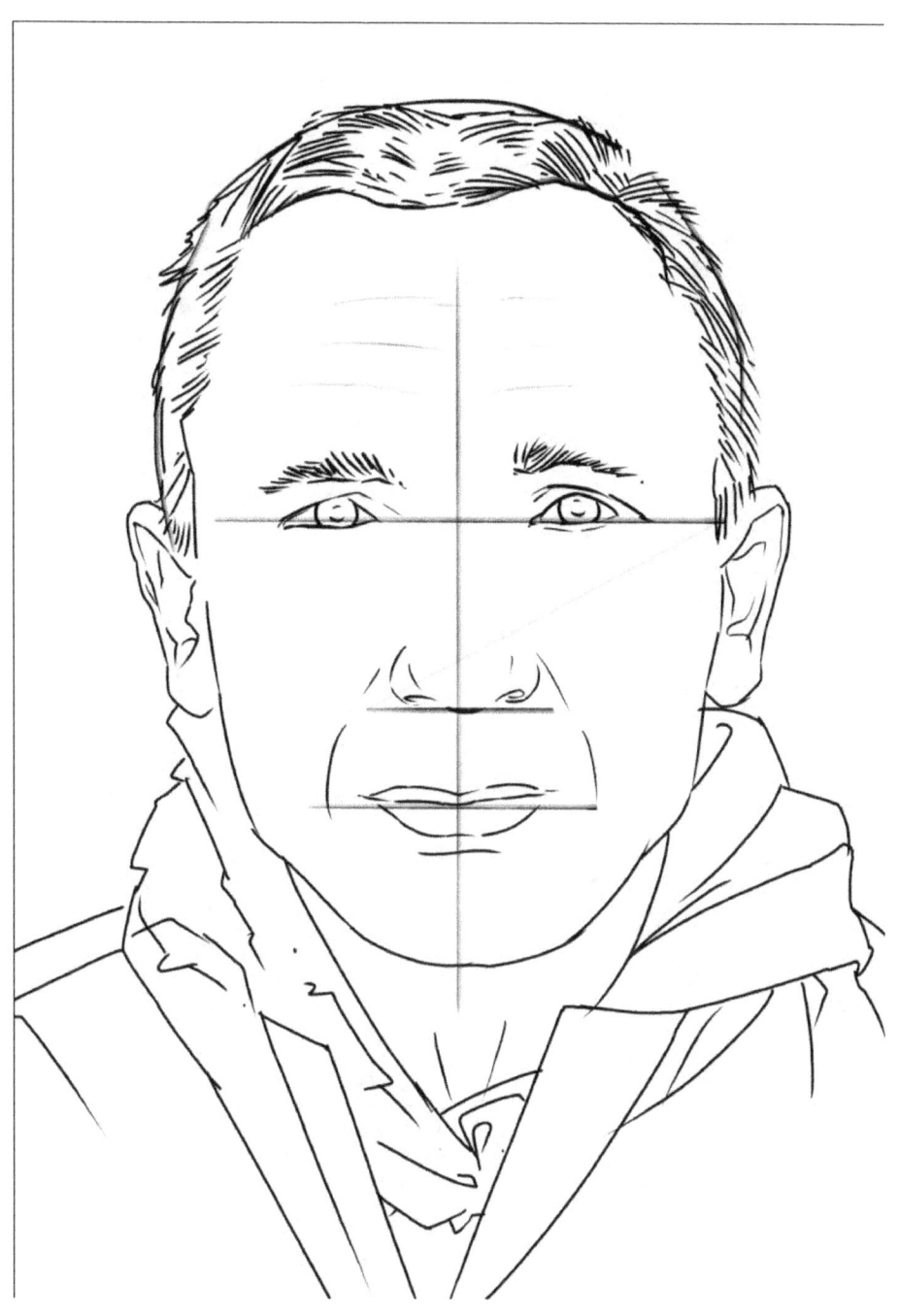

Step 6
Create some wrinkles under his eyes.

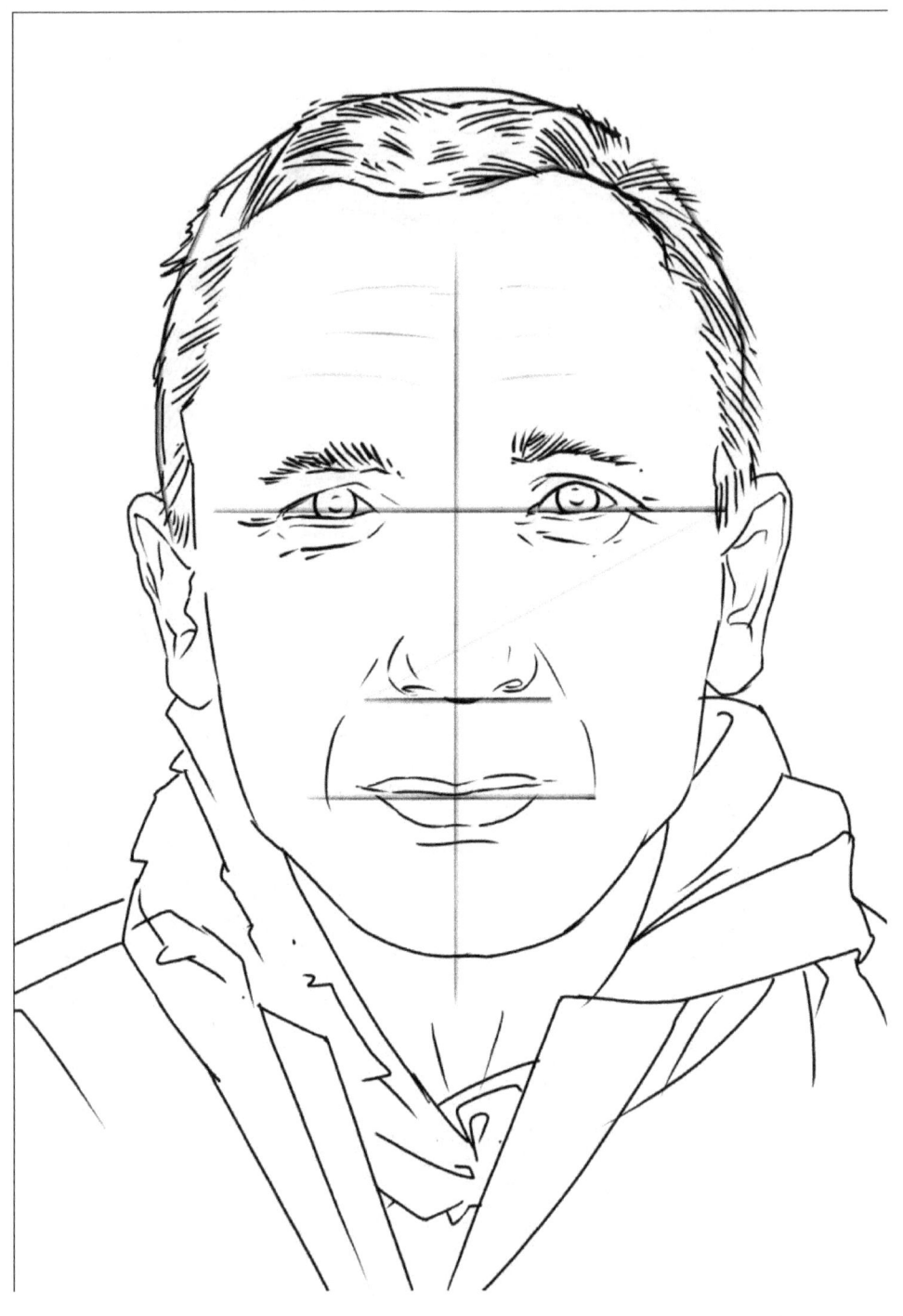

Step 7

Remove the vertical and horizontal lines that were meant for the placement of facial features.

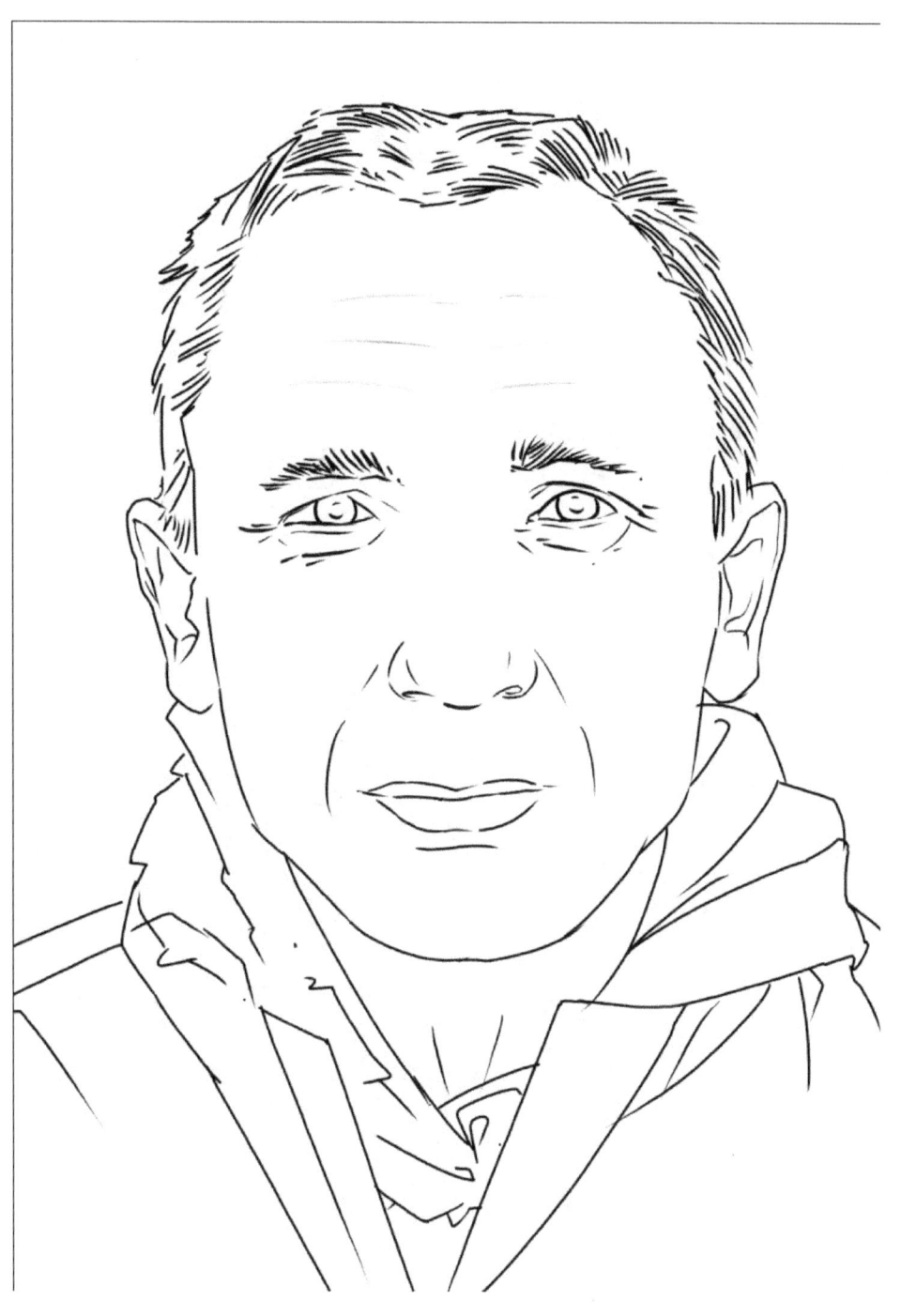

Step 8
Give a light gray background to the portrait.

Step 9

Give shading in his face, leaving eyes, nose, and mouth. Notice the changes in shading because of source of light.

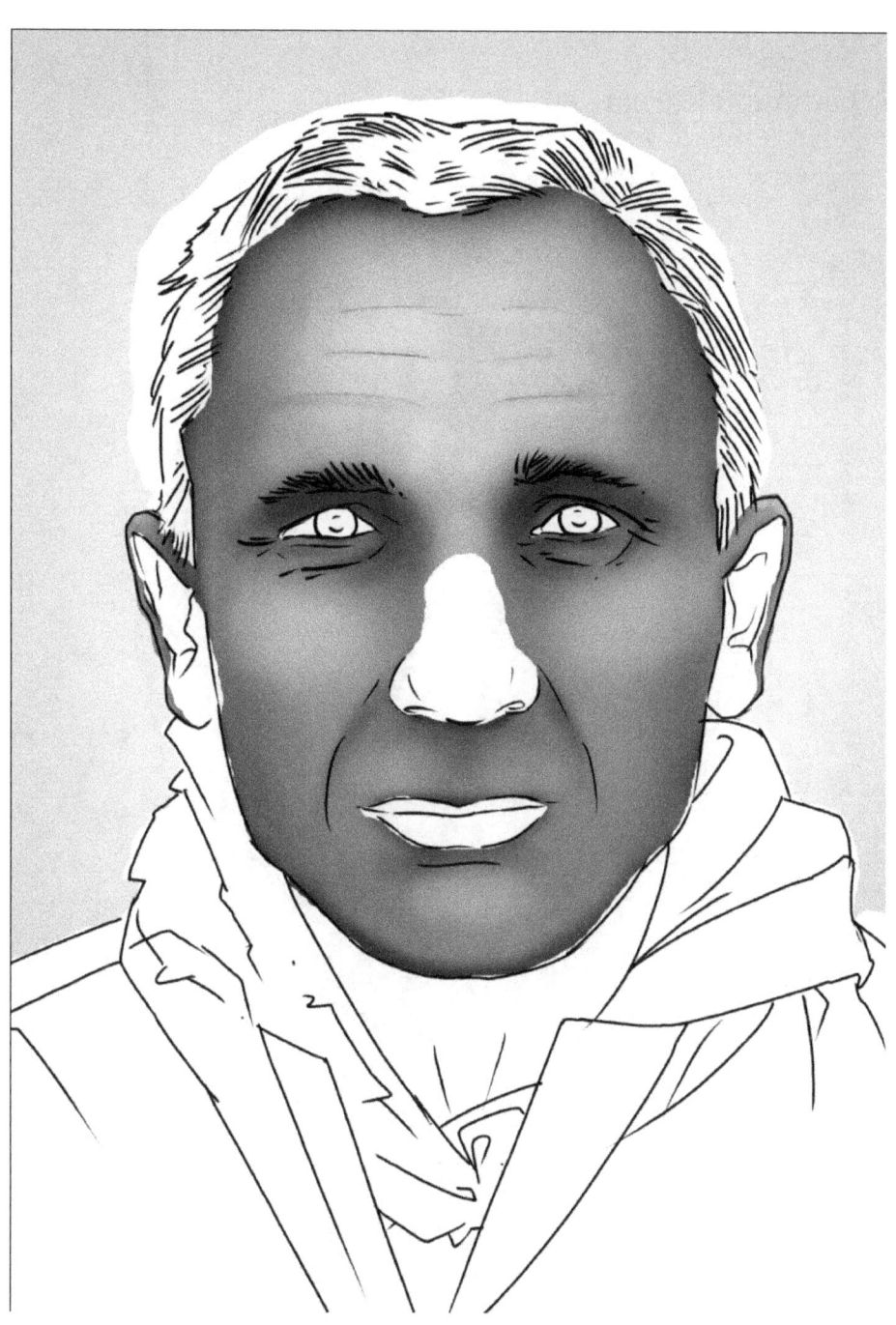

Step 10
Give dark gray shading in his hair, creating to layer of middle tone of gray between the hairs and the background for differentiation.

Give shading in the ears.

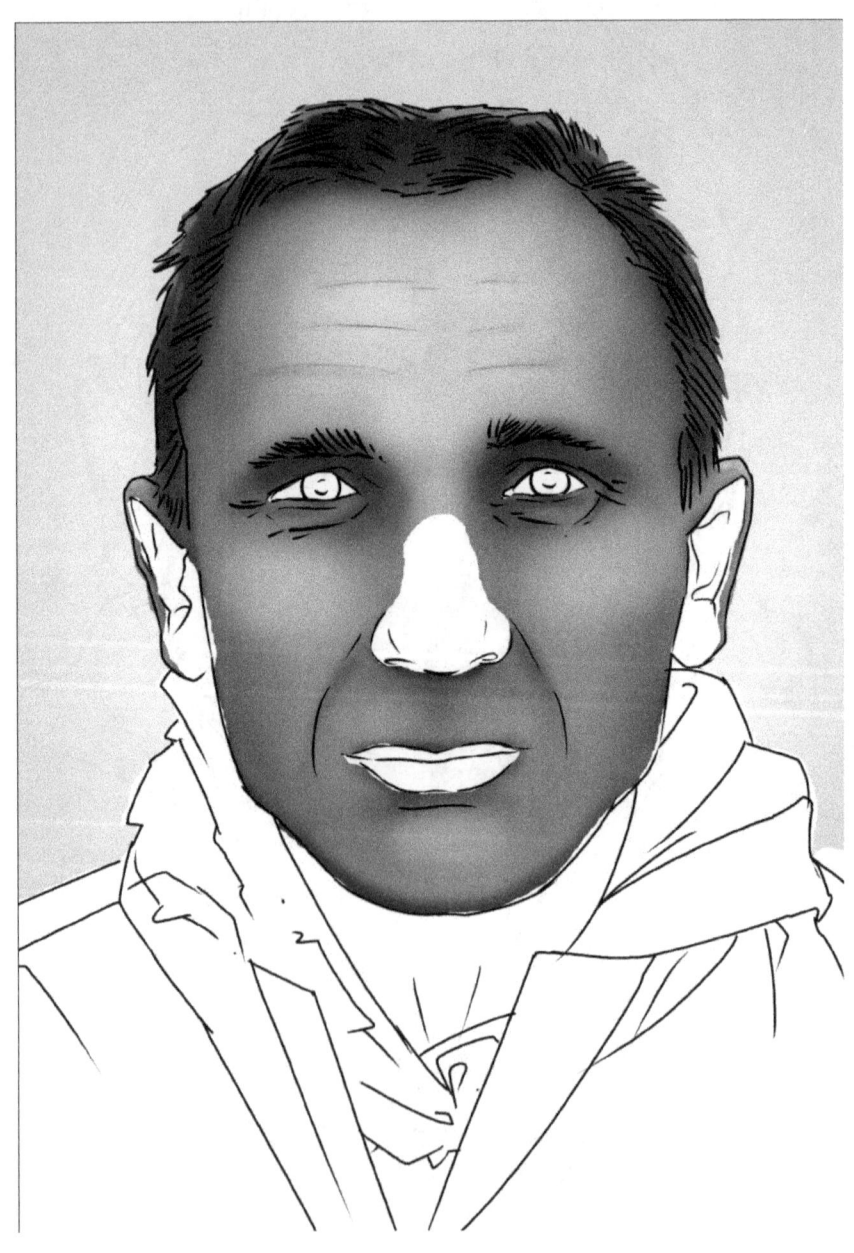

Step 11
Give shading in the lips.

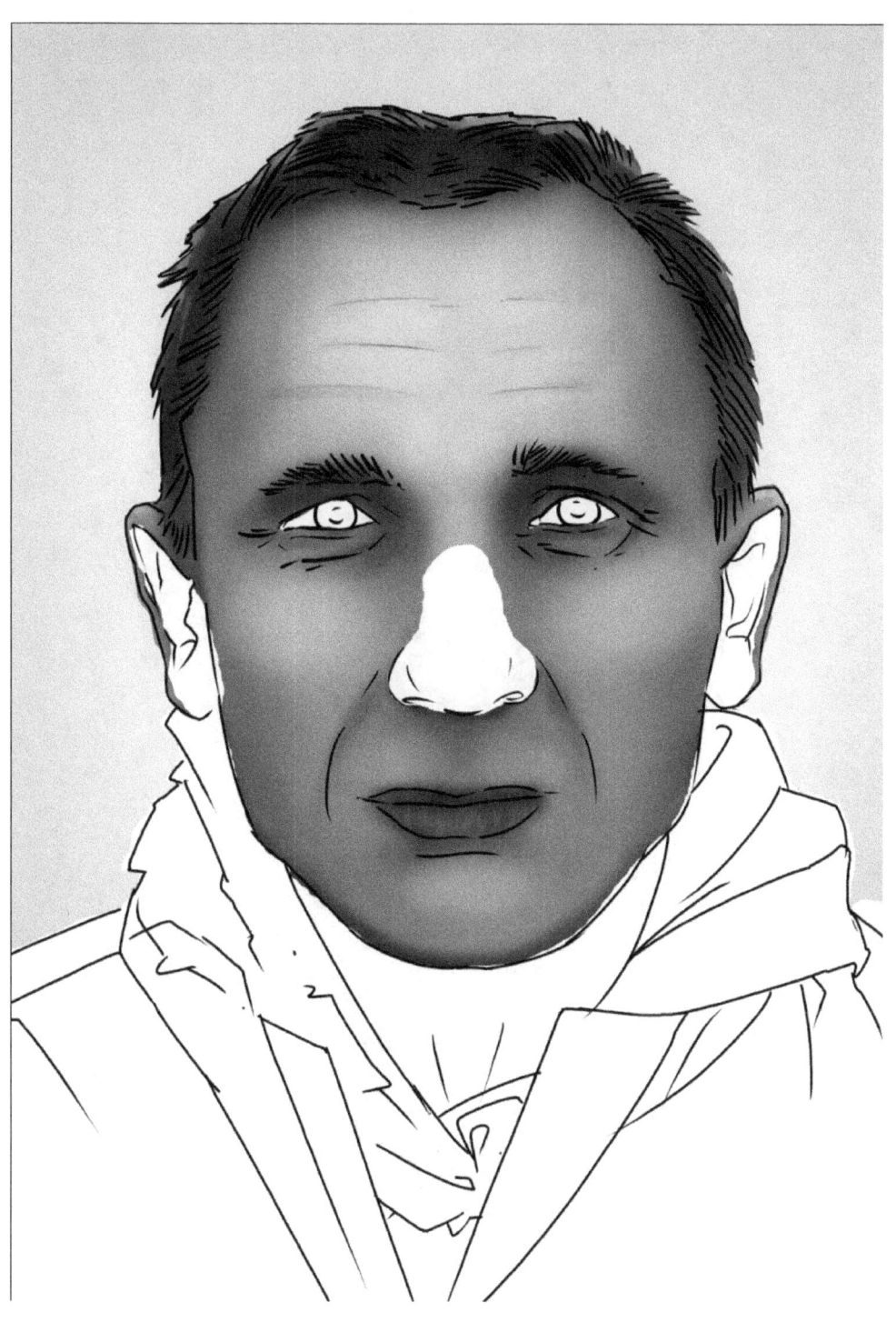

Step 12
Give shading in the eyes and nose.

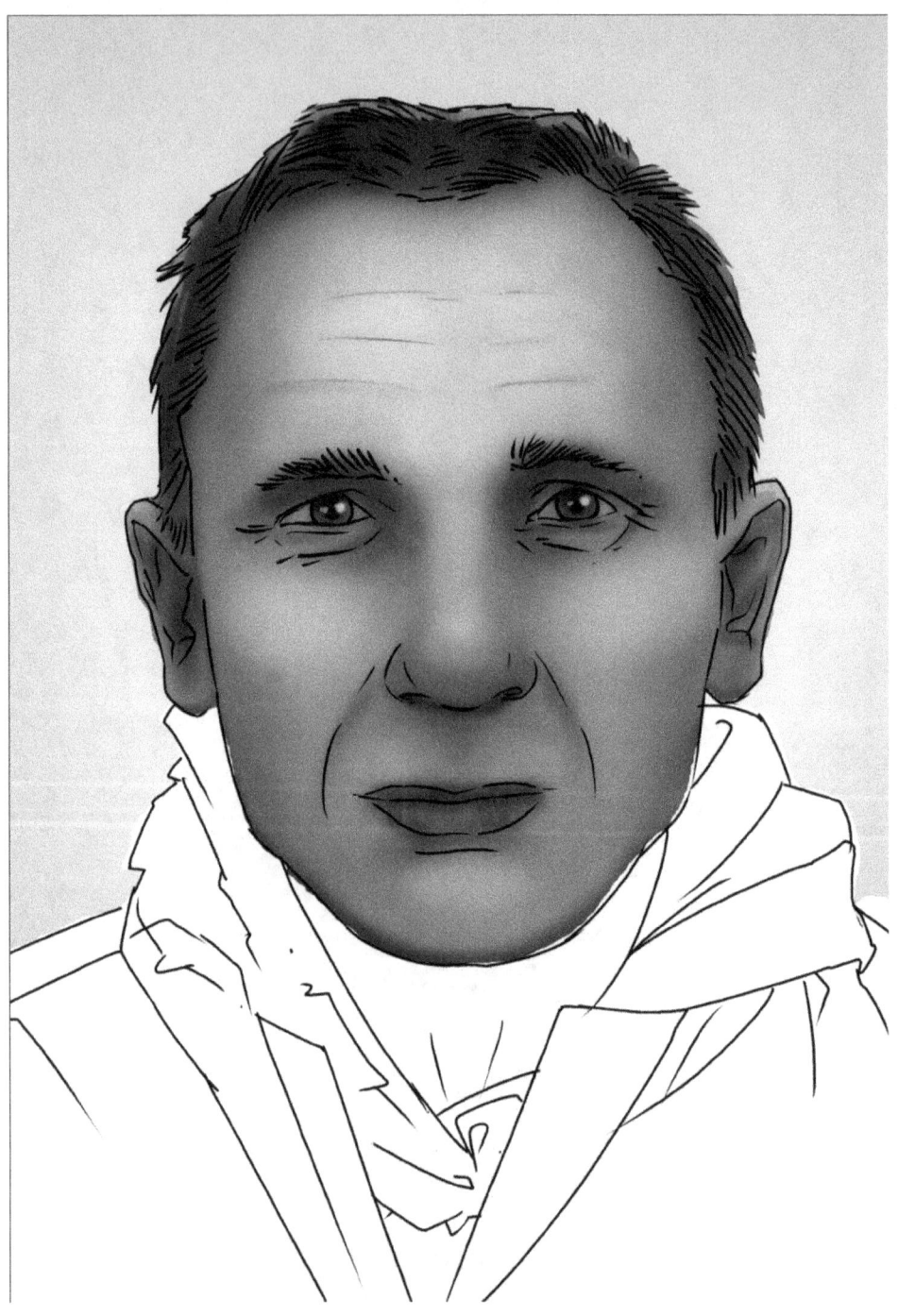

Step 13
Give shading in the neck.

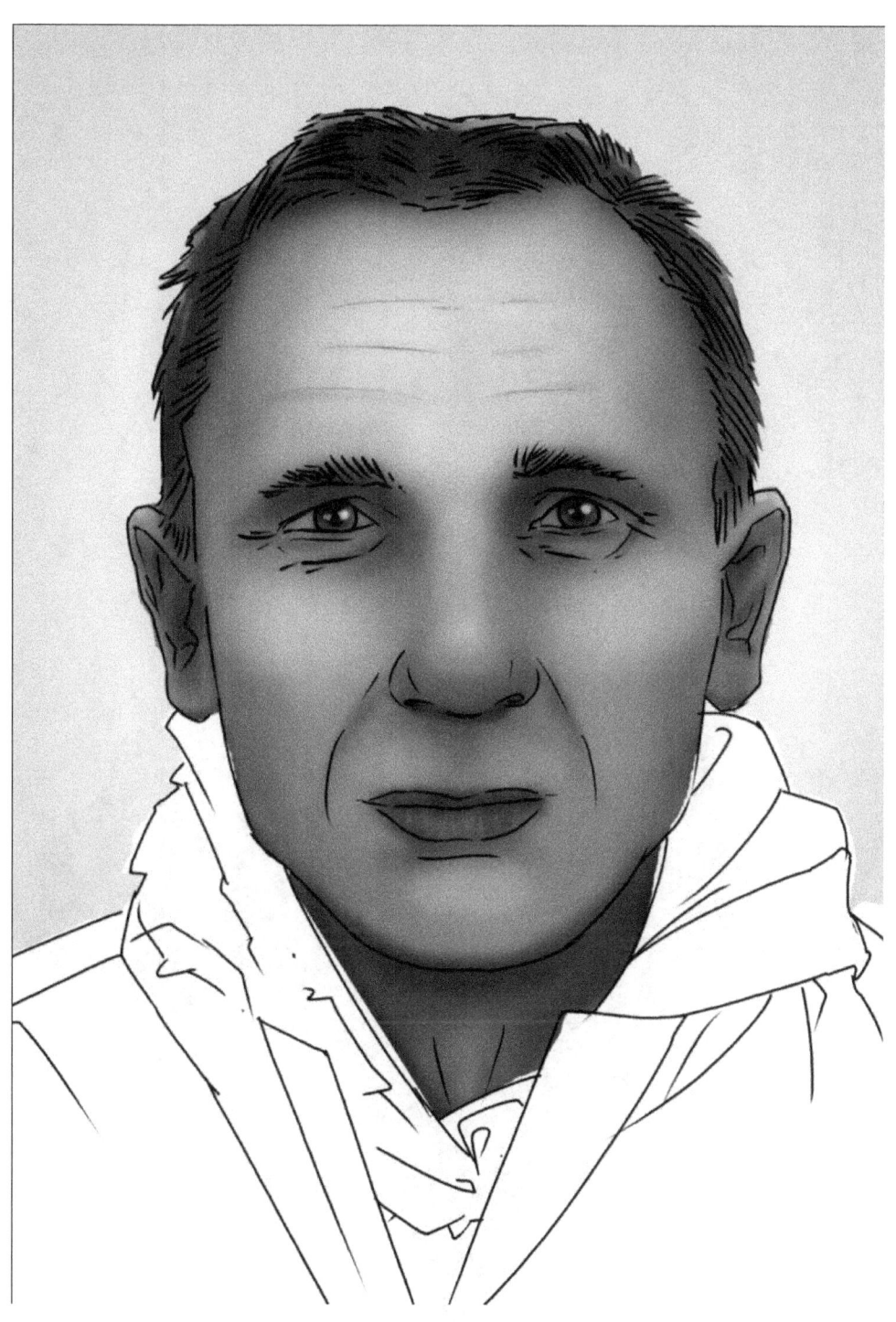

Step 14
Give shading in the collar of his jacket.

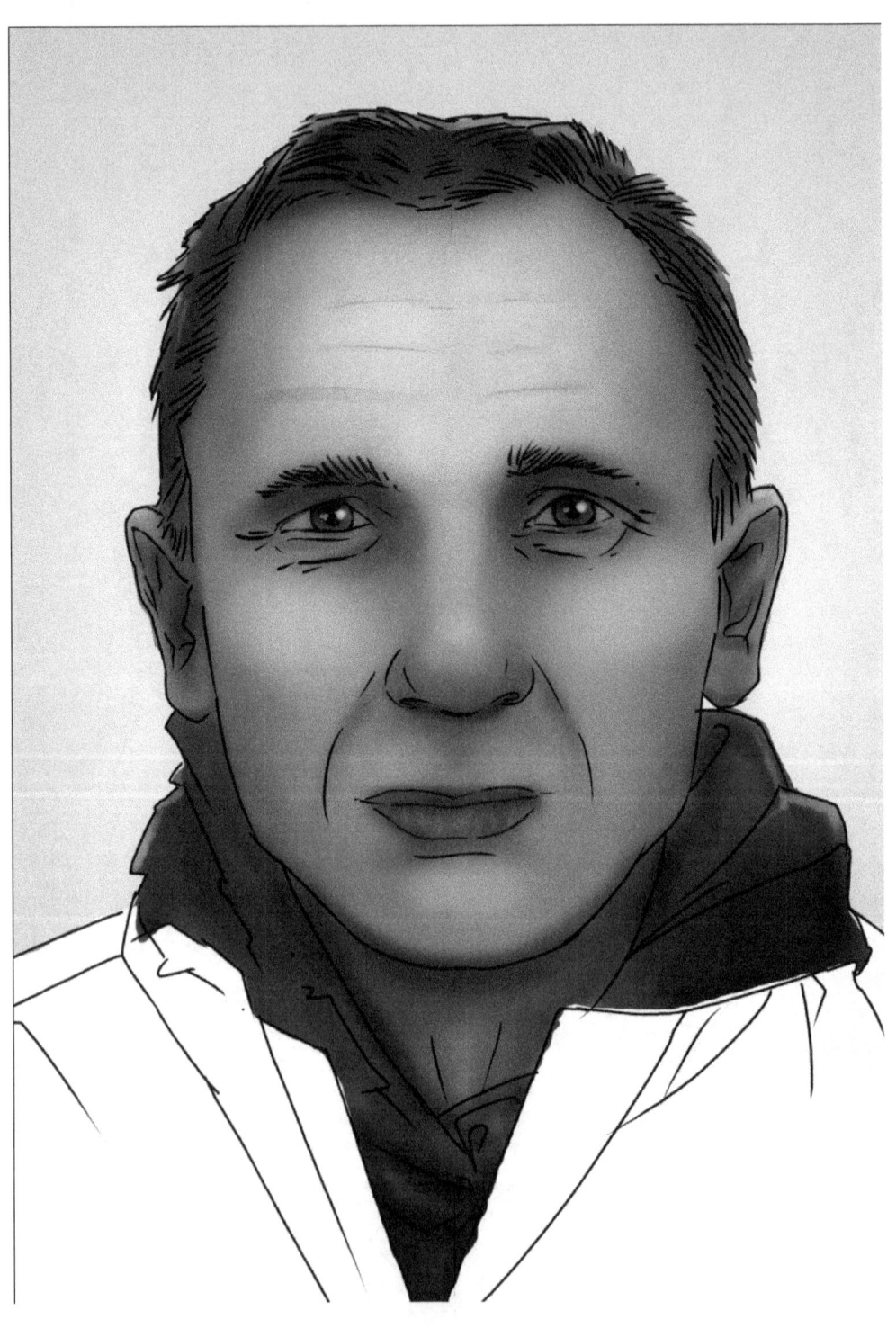

Step 15

Give shading in the remaining jacket, which is darker than the collar. The portrait of Alexis is complete.

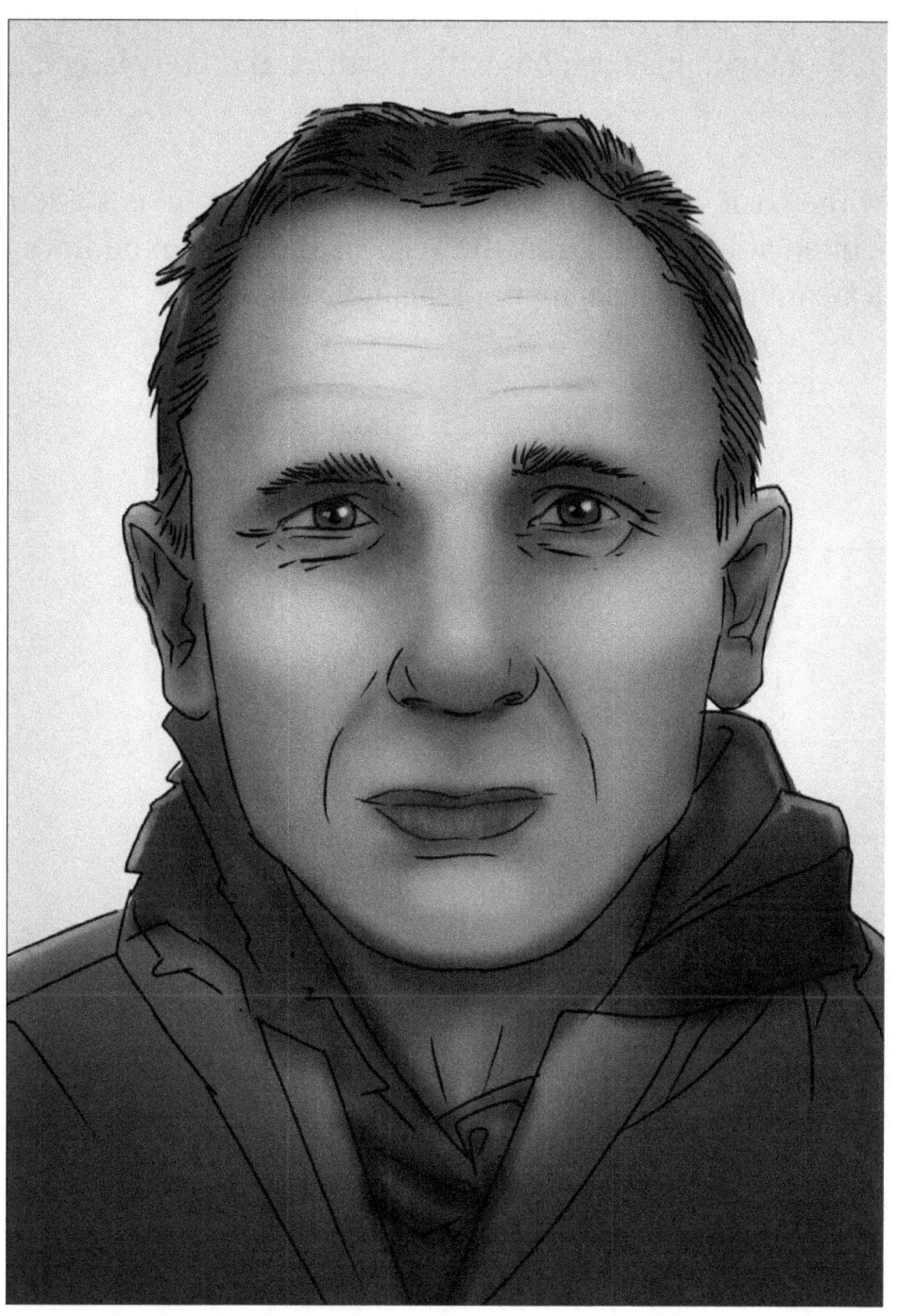

Chapter 7
Portrait of Jacob (male)

Jacob is a young male in his 20s, who displays details in his portrait not with his face, but with his attire and body language.

Step 1

Draw the basic outline of Jacob's portrait where he is standing a little tilted at his back. Draw the vertical and horizontal lines that were meant for the placement of facial features.

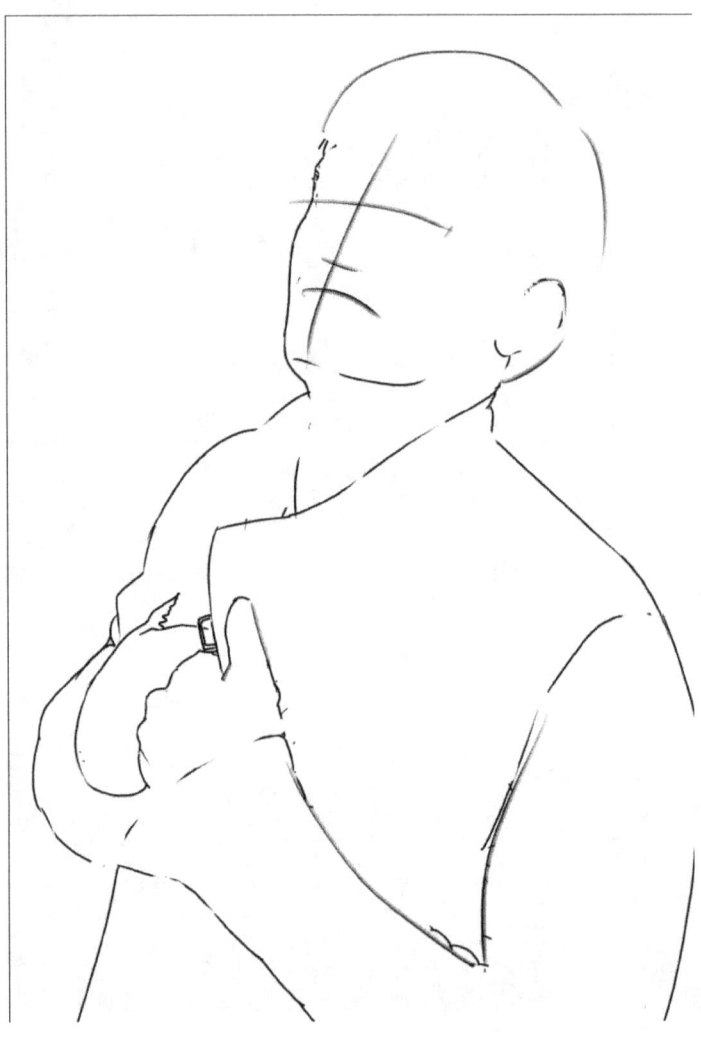

Step 2

Draw his hair's strands, which are dispersed in different directions. His hands are locked in his shirt as if he is trying to open the buttons of his shirt.

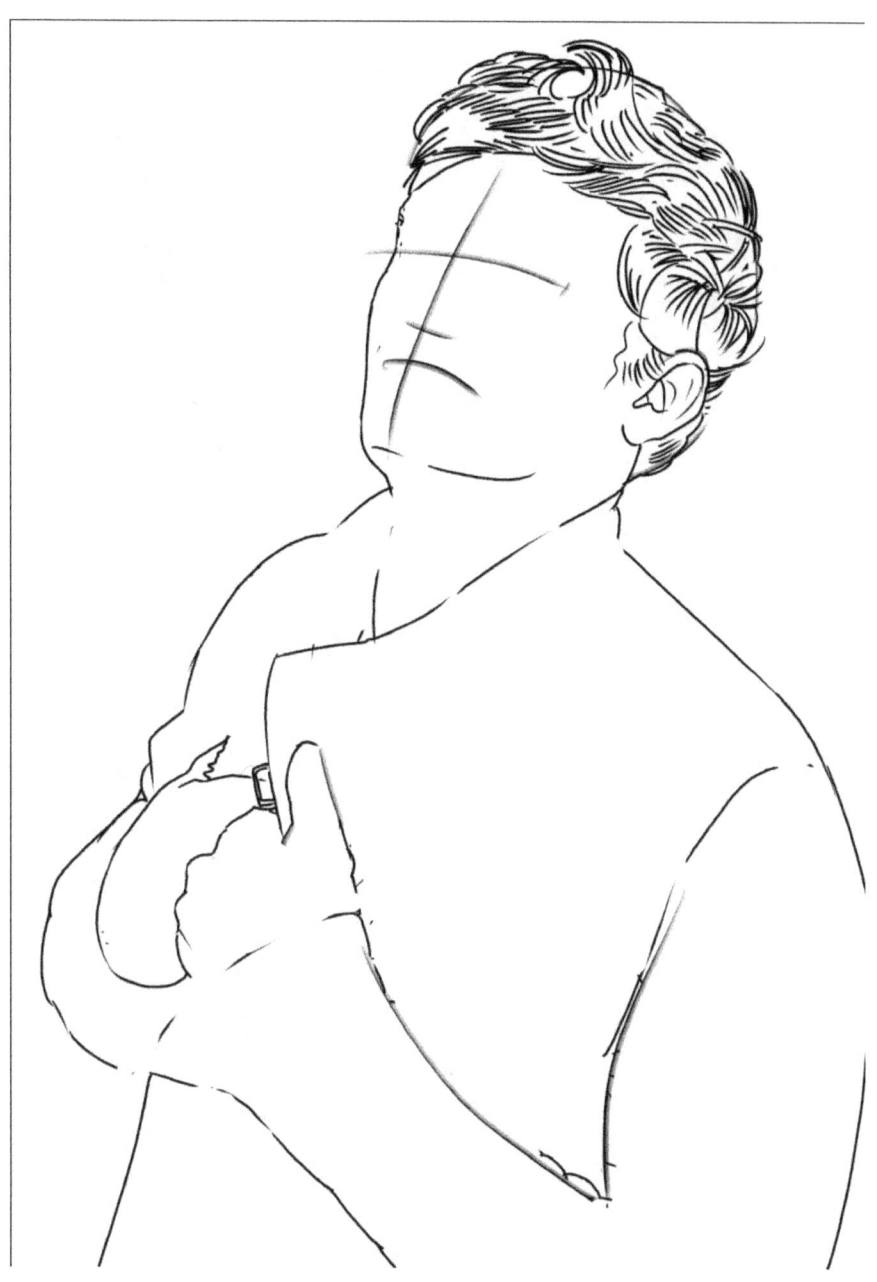

Step 3
Give details of his hands, including the nails, wrinkles, and nerves.

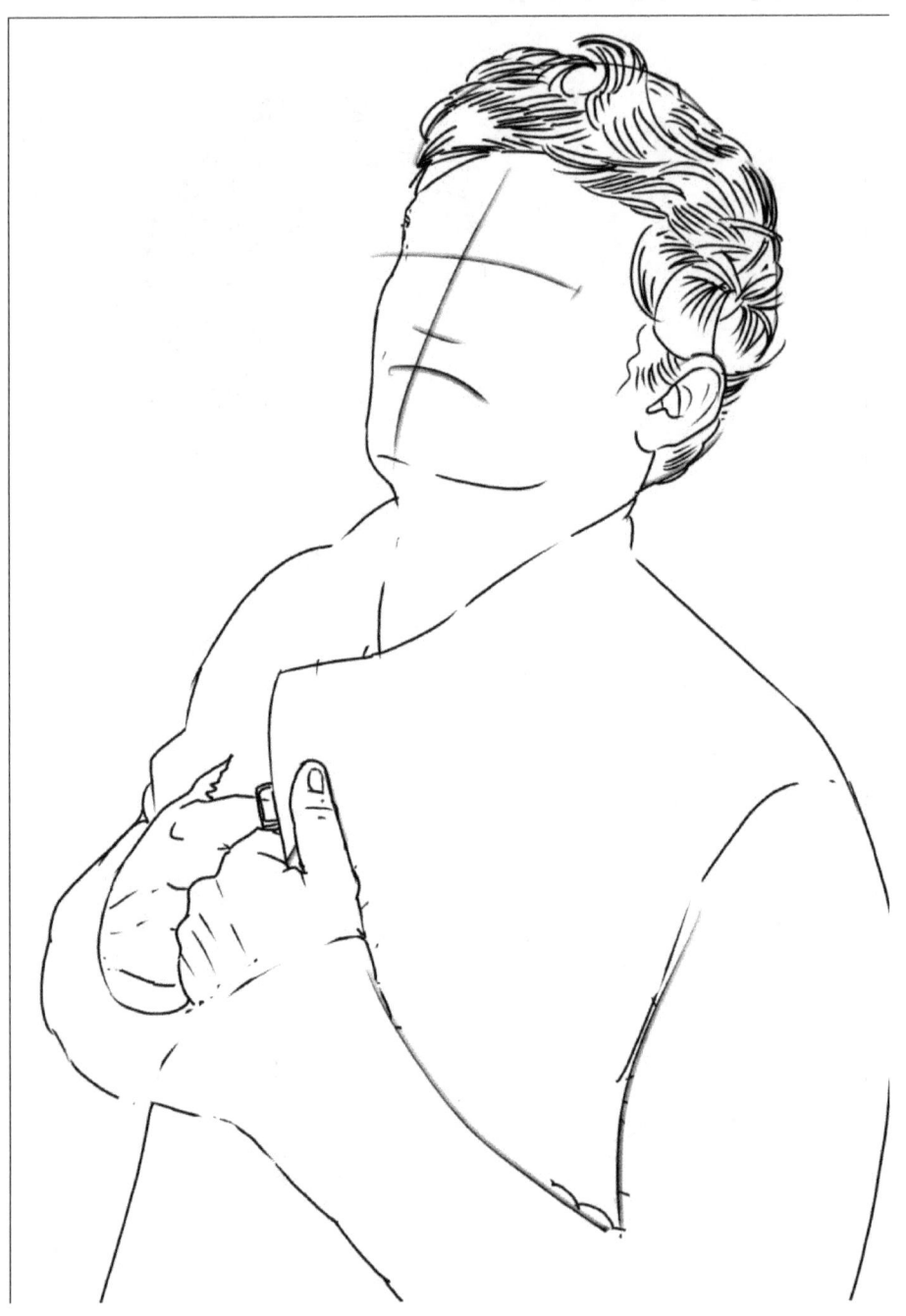

Step 4
Give details to his eyes, nose, lips, and ears.

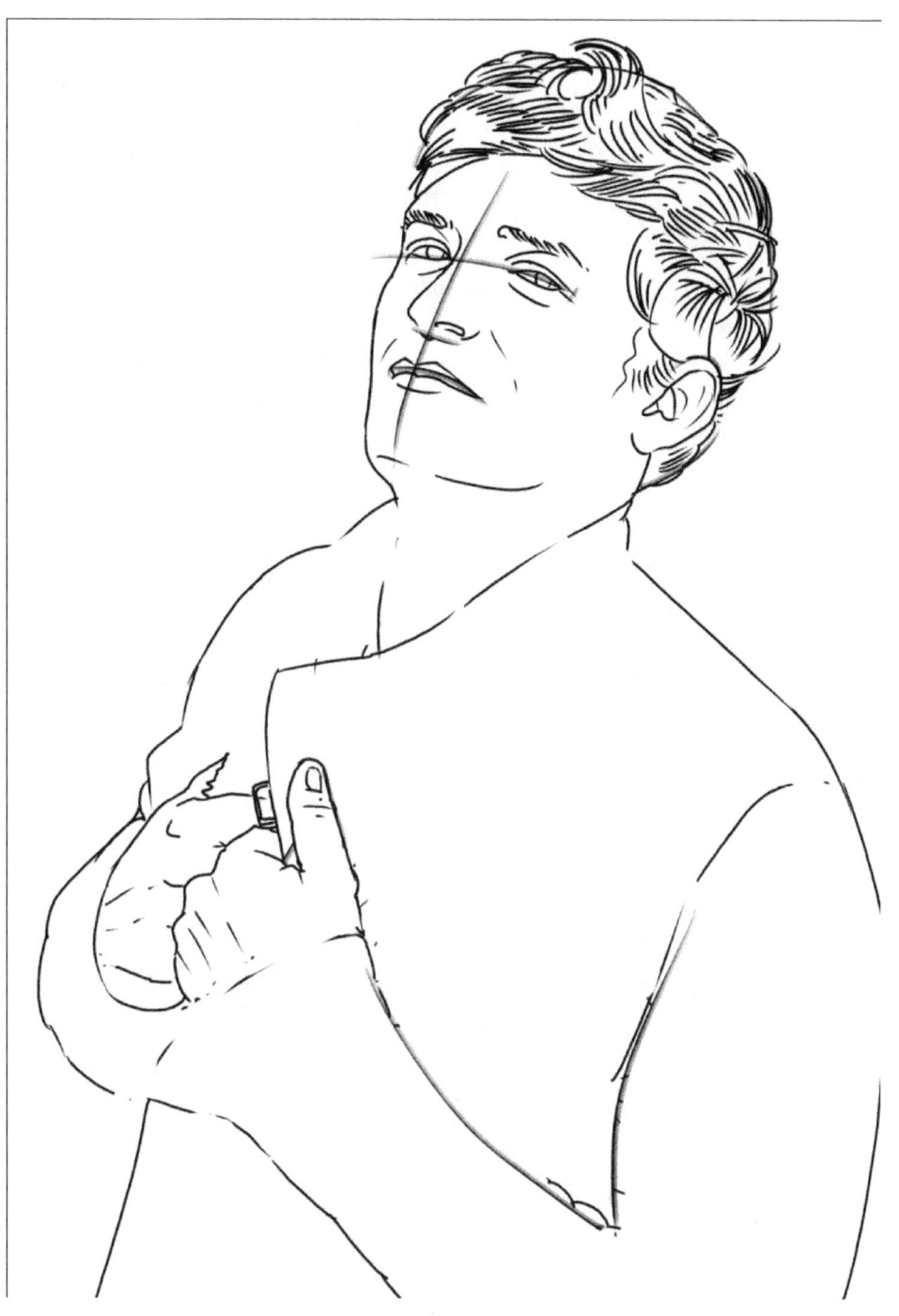

Step 5
Give details to his clothing such as a little fabric detailing on the sleeve whole and creases all around his jacket.

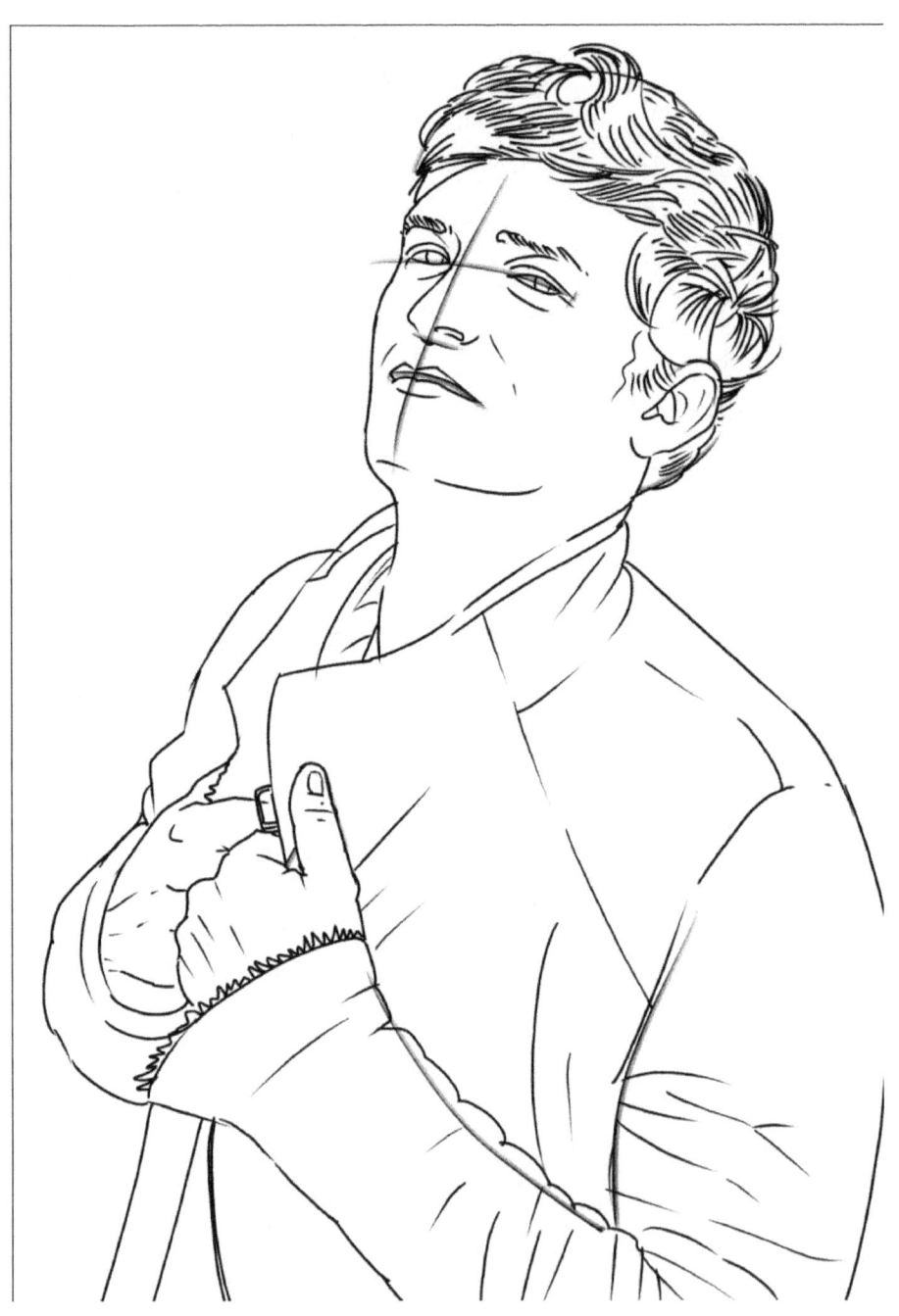

Step 6

Remove the vertical and horizontal lines that were meant for the placement of facial features.

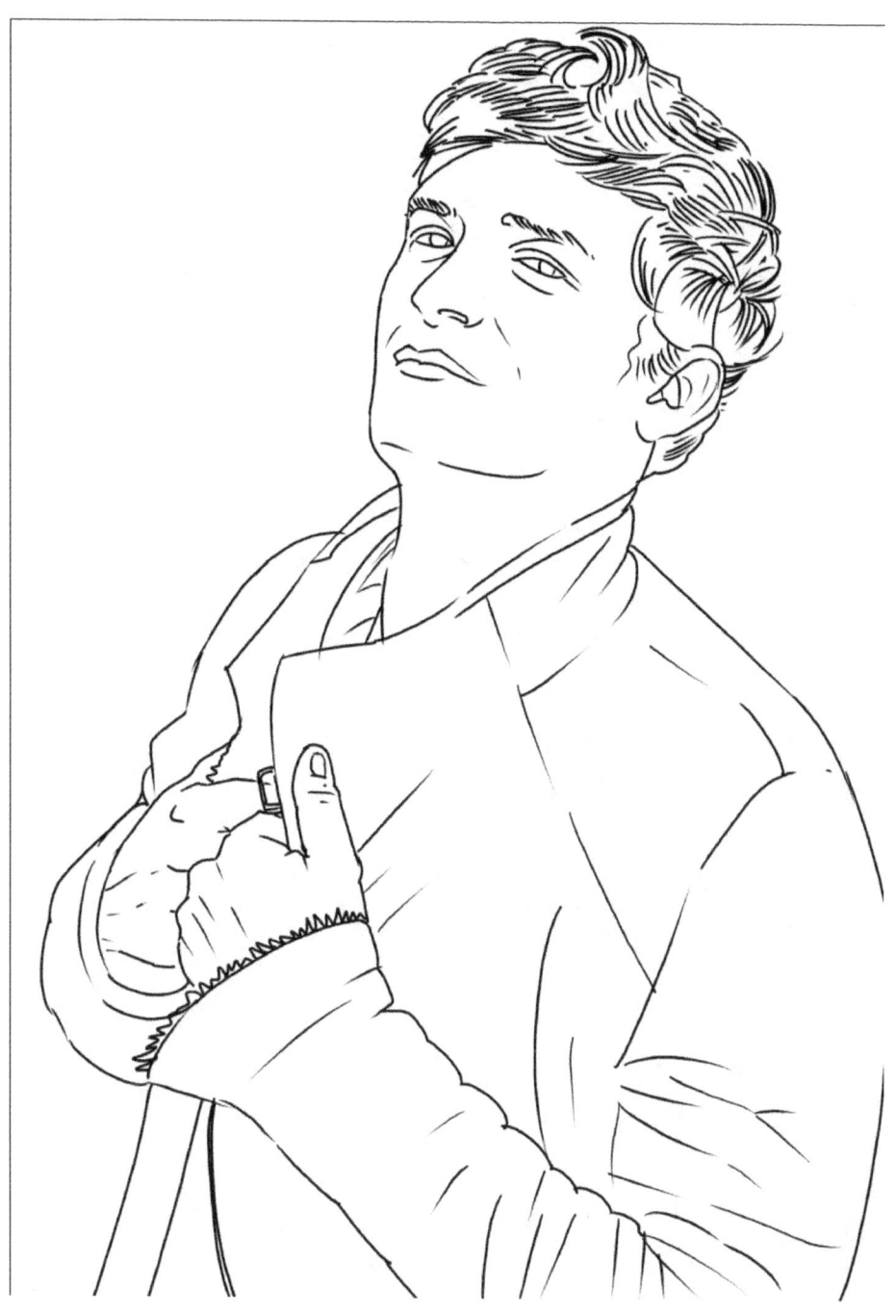

Step 7
Give light grey shading in the bottom left corner of the background of Jacob's portrait.

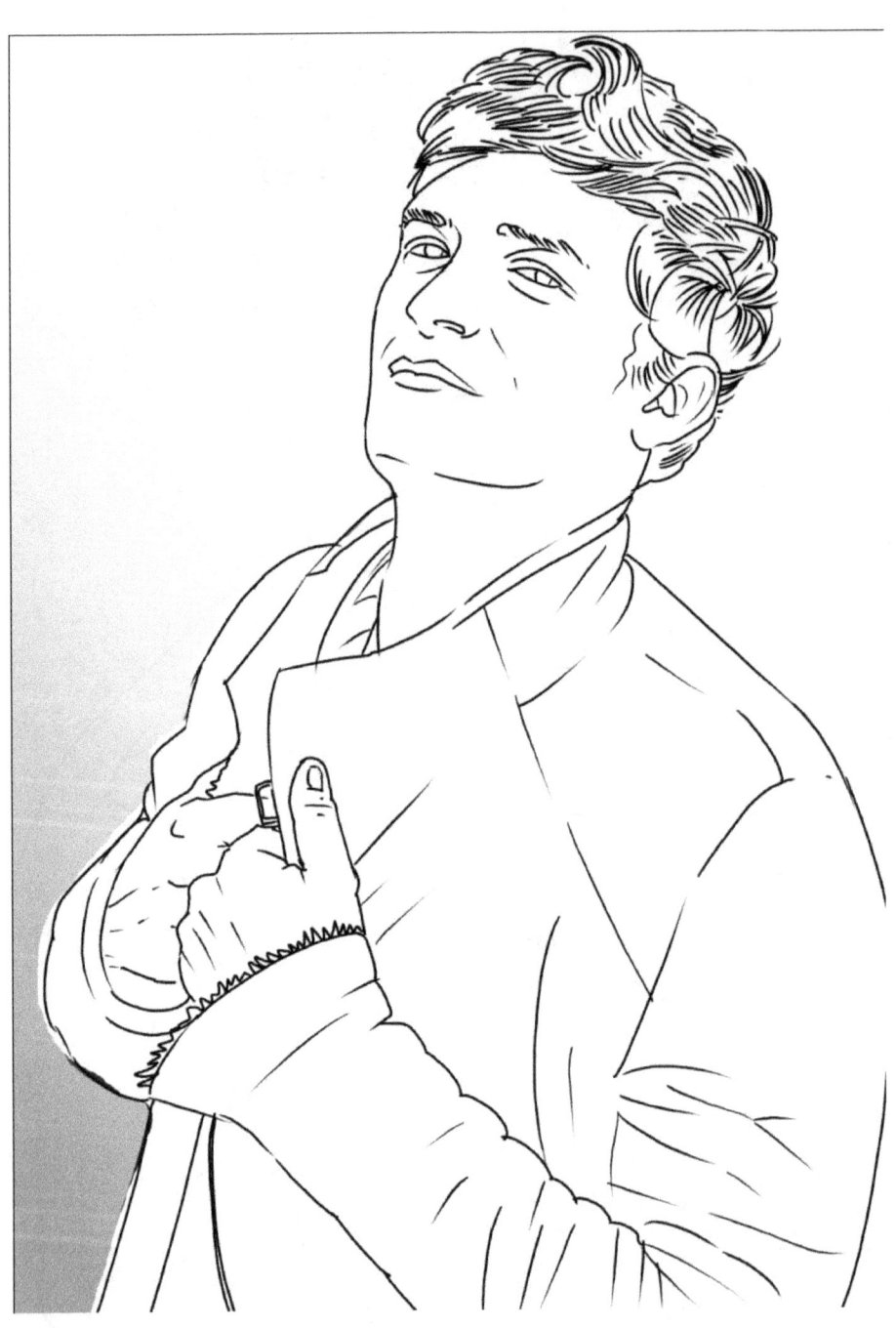

Step 8
Give shading in the clothes of Jacob.

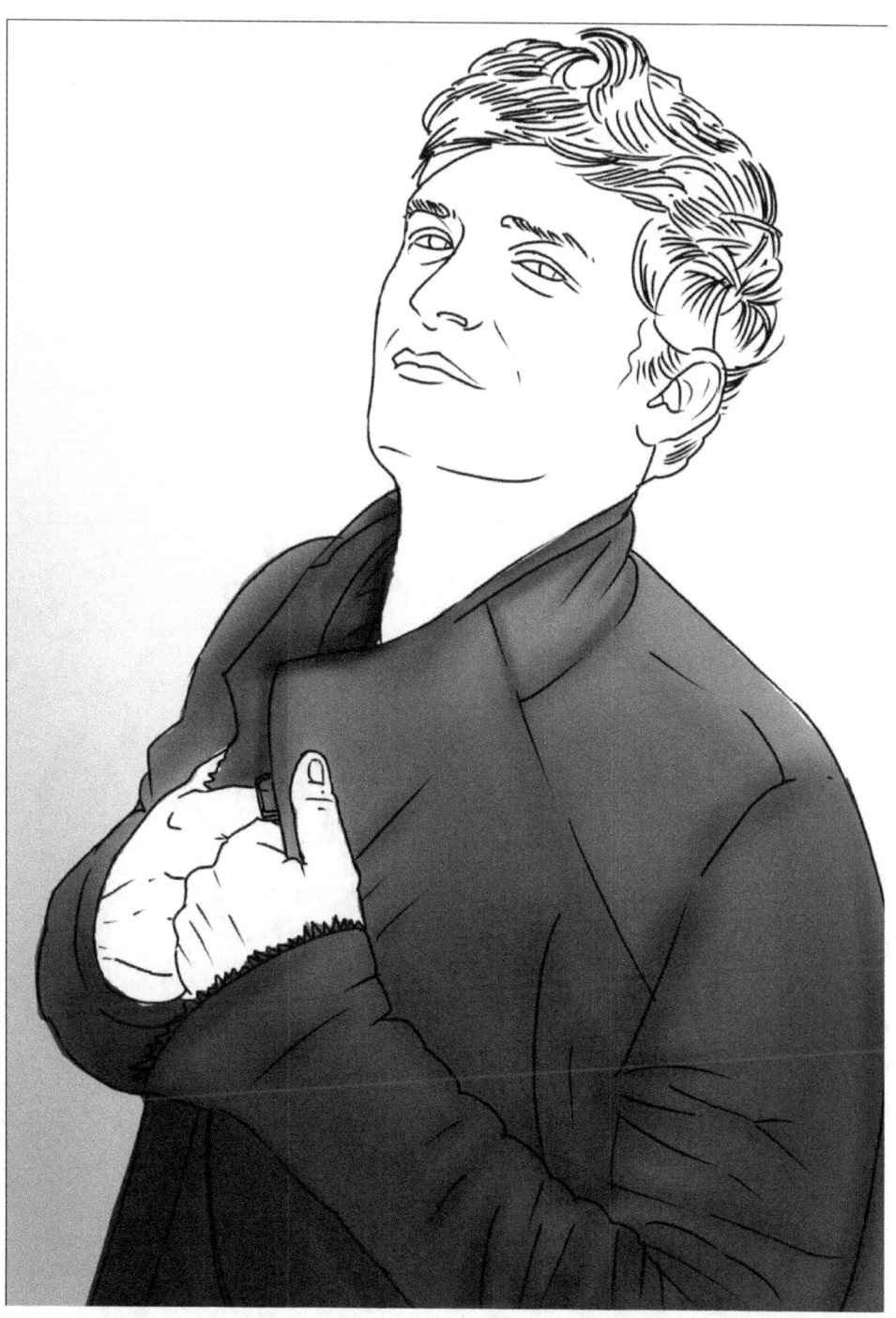

Step 9
Give shading in his hands.

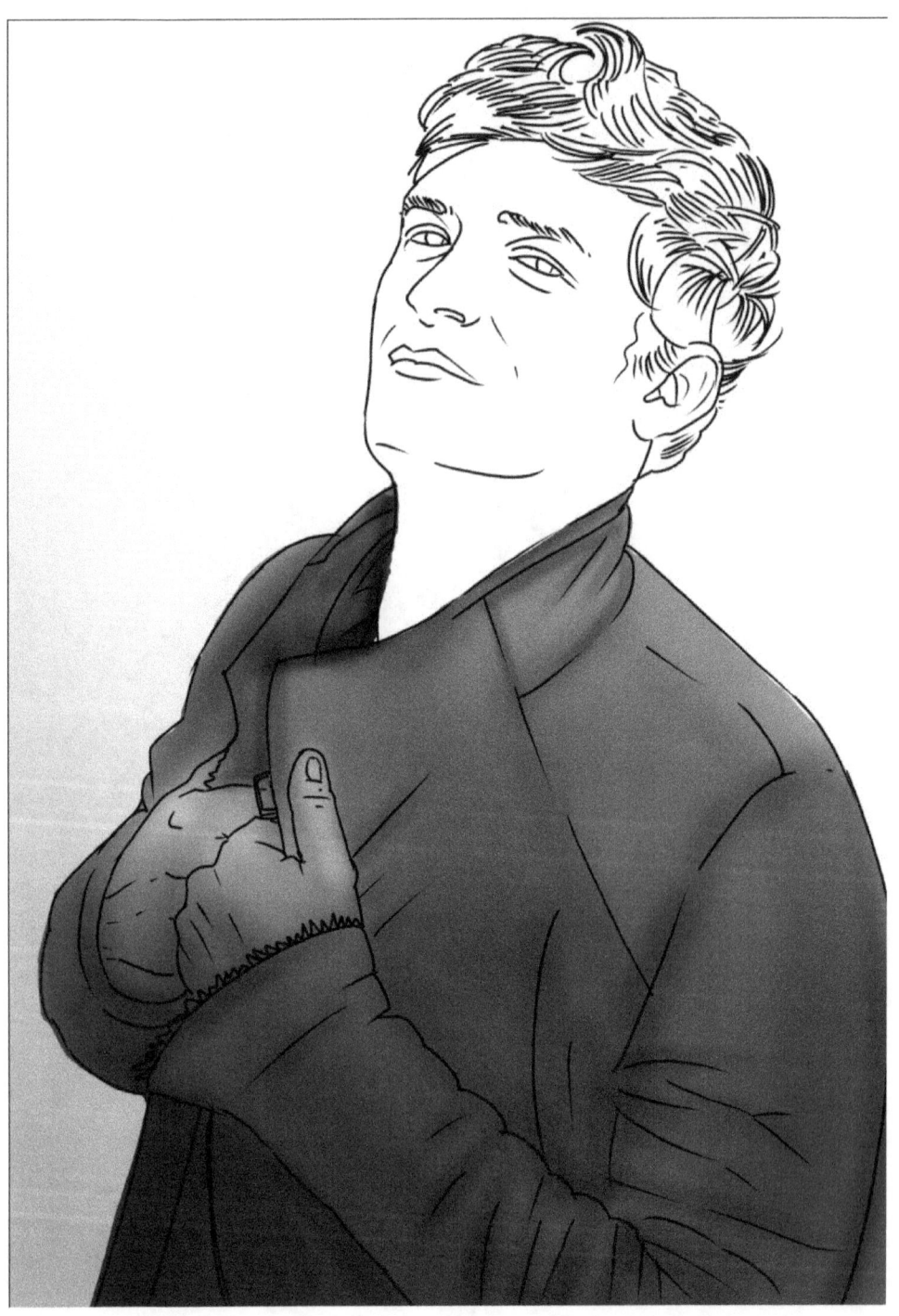

Step 10

Give shading in the face and ears of Jacob, leaving eyes, nose, and mouth.

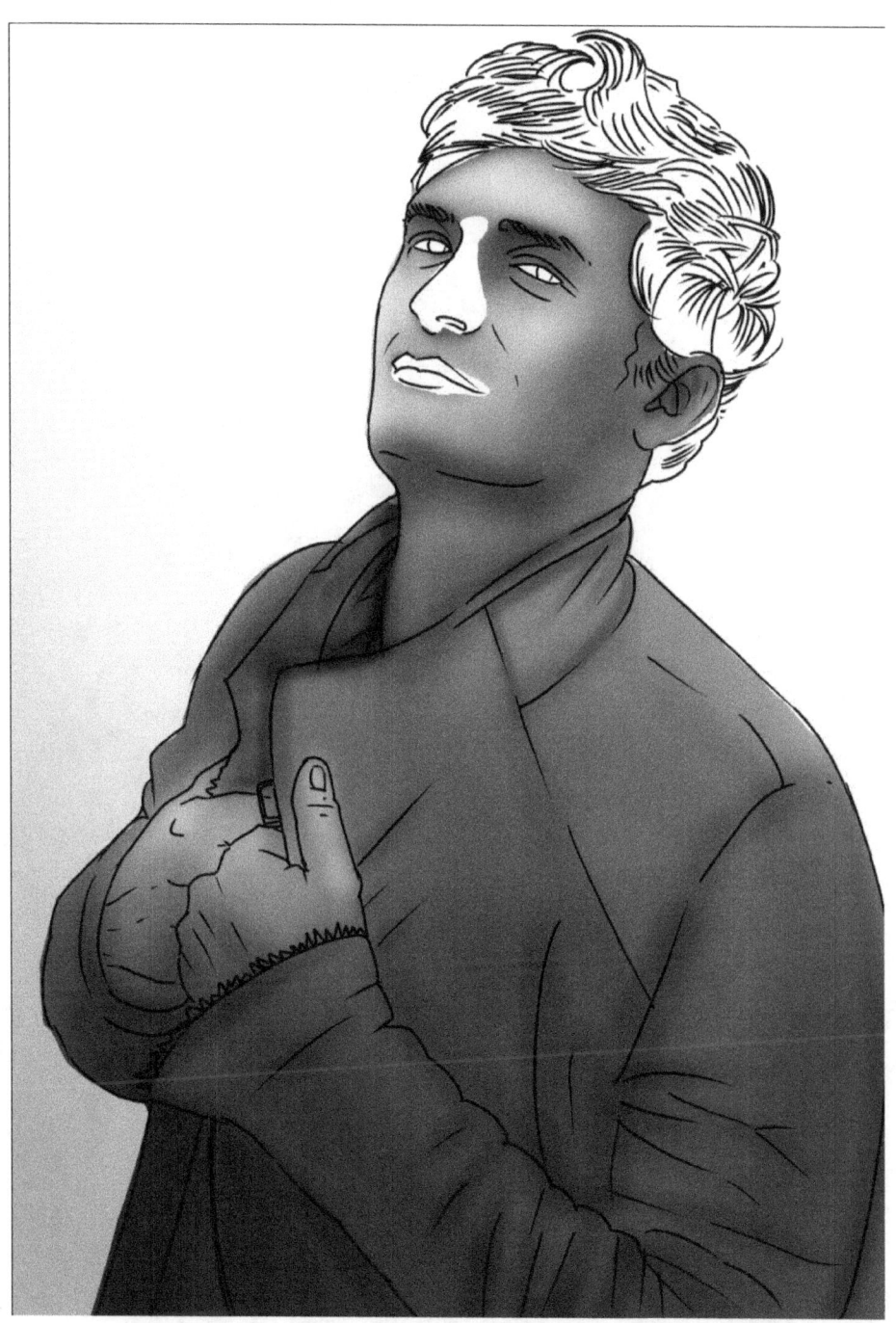

Step 11
Give shading in his hairs.

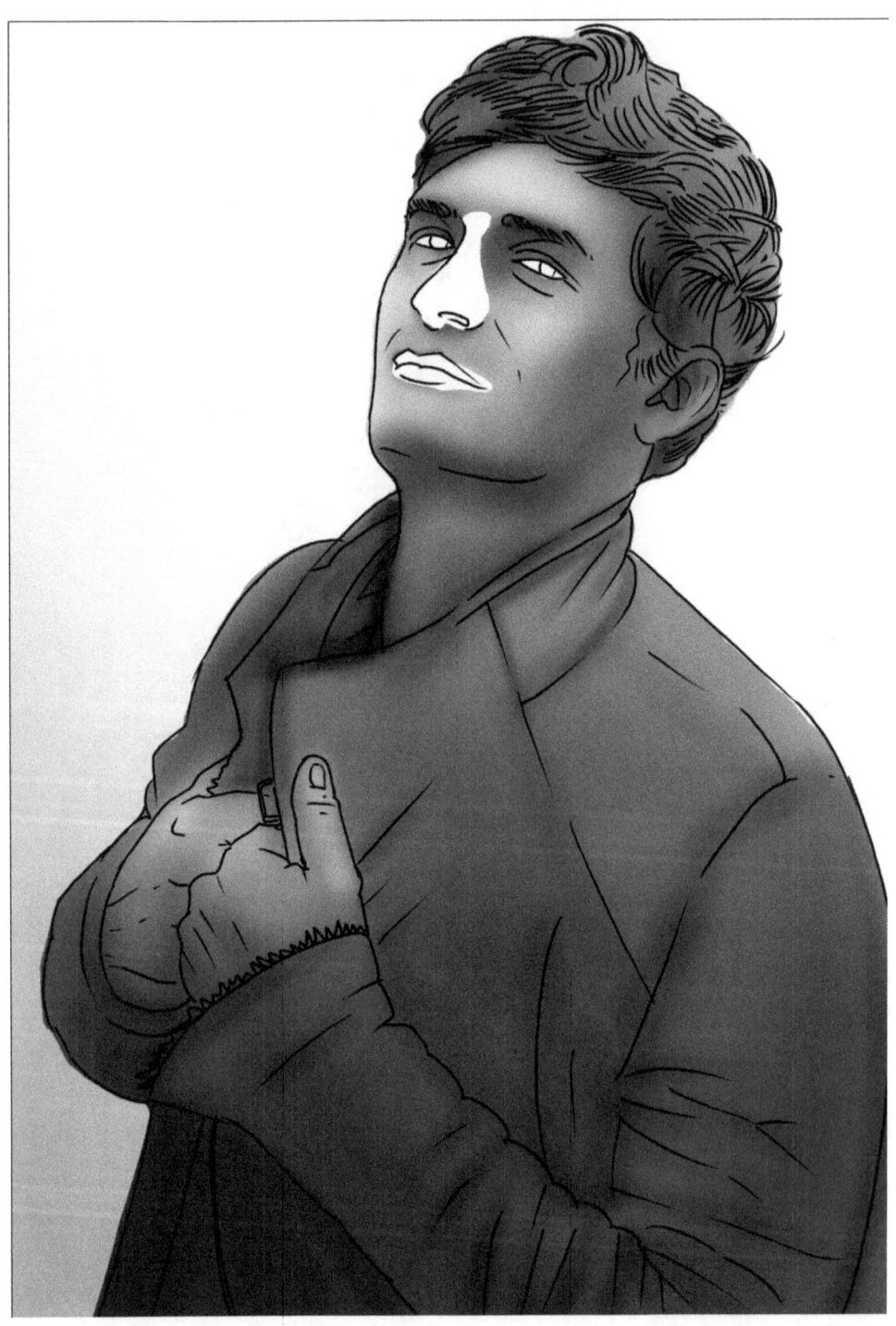

Step 12

Give shading in his eyes, nose, and mouth. Since he is not an old man, his face does not show many wrinkles. The portrait of Jacob is complete.

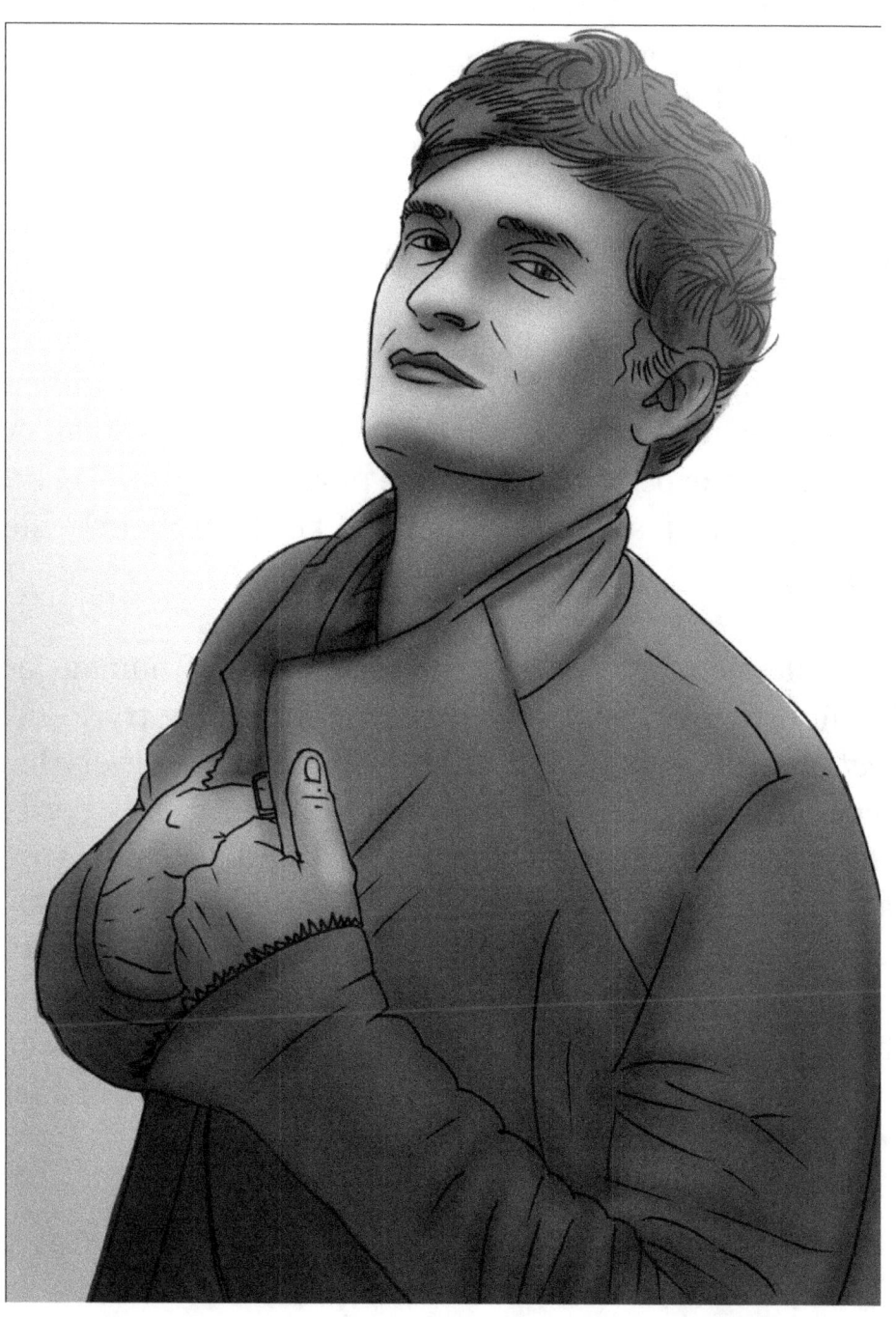

Conclusion

Portraits given in the illustrations of this book may seem relatively easy to you. Since these portraits are drawn with the help of computer software, you will have to double your efforts when you draw them with pencil and charcoal. The main idea of this book is to introduce you with the process of portrait drawing. The rest of the efforts are up to you.

You can read any number of books you want and go through any number of tutorials on YouTube. Everything is worthless unless you shed your hesitance, pick up the drawing equipment, and begin drawing. The first step is the only step that is difficult to take. You do not have to make much effort after that. Many people become expert in drawing the human body, but lag behind in drawing faces just because they are hesitant about achieving the likeliness.

A nonprofessional artist has a pre-set image of human face in their mind. When they try to draw the face, they try to draw a *perfect* nose, *perfect* eyes, *perfect* lips, and *perfect* everything in the face. However, the fact is that no human face is perfect or identical to each other. If you look around yourself, you will always find the most beautiful people in the world complaining about their face or body. Keeping this fact in mind, you just have to draw a face as you see in the picture. Do not try to perfect the portrait; it will spoil the originality of the person's face. Just draw what you see. If there is a black mole, or the eyebrows of a female are not identical, draw them as they are.

You will be amazed at the results you achieve. If you stop trying to perfect a portrait, you will get great results as they are meant to be. You can ask your friends and family to pose for you so that you can get free high- resolution images. If you get bored of drawing human faces, you can even draw your pets for a change. However, drawing animals is a completely different genre. But you have to take a break from everything sometimes. Do not feel bad if you feel saturated from drawing. Just take a breather, have some fresh air, and get back to work as soon as you can.

Finally, as it is stated many times before, you need to give deliberate practice to portrait drawing. No artist becomes great by creating art works once in a week. You have to fail a hundred times before you succeed once. Finally, when you succeed, your success speaks for your failures.

Thank you!

Thank you for choosing our book, we hope you found it interesting and helpful.

If you liked the book, please give us a favor to write your review.

We would really appreciate this!

If you would like to have a bonus – **FREE BOOK**, please send the screenshot of your review to this e-mail: **kelly.artbooks@gmail.**com and we will send you a **FREE BOOK** in PDF as a **GIFT!****

Hope to see you in our future books and good luck in your drawing experience!

**** in the e-mail subject please mention the name of the book you reviewed and the author.**

www.ingramcontent.com/pod-product-compliance
Lightning Source LLC
Chambersburg PA
CBHW080717190526
45169CB00006B/2405